Unless Recalled Earlier

DATE DUE

DEMCO, INC. 38-2931

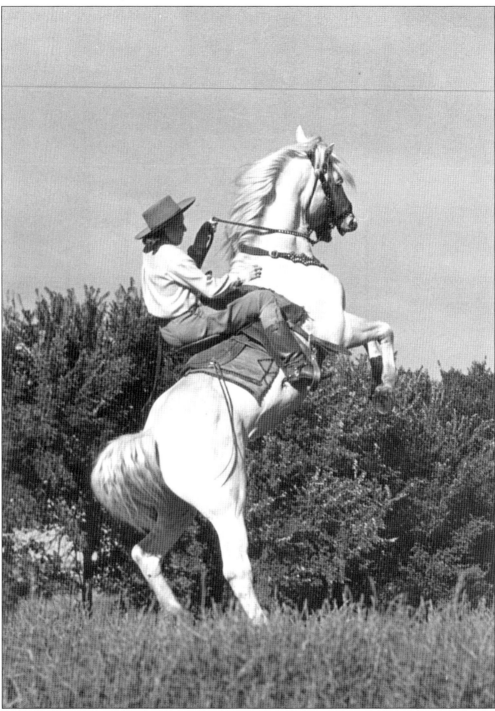

This spirited horse and rider perhaps best represent the enthusiasm and flavor of Rapid City at the western gateway to the Black Hills and its summer vacationland.

The "Star of the West" welcomes you.

IMAGES
of America
REMEMBERING
RAPID CITY
A NOSTALGIC LOOK
AT THE 1920S THROUGH THE 1970S

Bev Pechan and Bill Groethe

ARCADIA

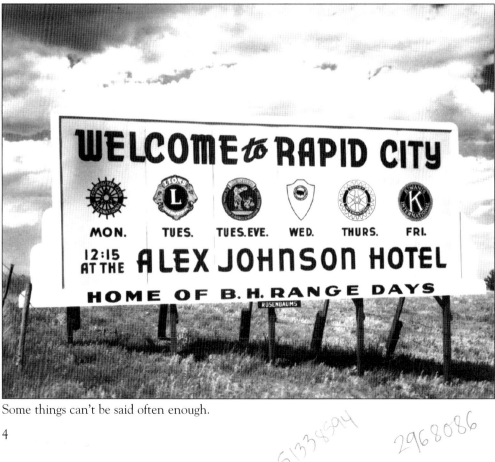

Some things can't be said often enough.

CONTENTS

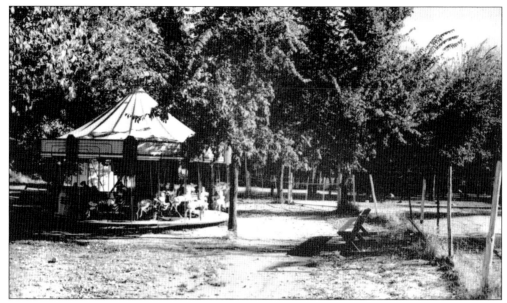

This deserted carousel at Rockwell Park Kiddieland is representative of fading memories that are gone all too soon. The little amusement park was in the Canyon Lake area in 1953, but few can recall its existence.

ACKNOWLEDGMENTS

No writing effort is complete without the help of others who generously share time and knowledge to create the bigger picture. When approached to do this book, my immediate thought was to use the vast collection of Bell Studio images taken over the past three quarters of a century. Master photographer Bill Groethe was a member of the Bell Studio team as a young apprentice not yet in his teens, and, at 79 years old, he is still operating his own commercial photo business in Rapid City. Bill has exclusive ownership of the early Bell collections.

Knowing there were wonderful and primarily unpublished images out there presented another problem, however, in that they had never been catalogued. With the help of Gene Mincks, we spent weeks going through boxes of hundreds of negatives, many of which had not been identified, but had dates—a place to start. Bill's graphic specialist, Brenda Hupp, provided invaluable service, often into the night, surviving multiple computer crashes to scan and rescan what I decided to use and then not to use. Thanks, Brenda and Gene!

And thank you to the following friends and professionals who helped me sort out some of the details: Verne Sheppard; Harry Petersen; Glenn Best; Wat and Olga Parker; Helen Wrede; Jim and Lois Halley; Eka Parkison; Ellen Bishop; Don Barnes; Mr. and Mrs. Dorrence Dusek; Joe Sanders; Sara Talley; Dave Strain; Louis Freiberg; Gene Sagen; Laura Tonkyn; Sister Celine Erk, archivist, Catholic Diocese of Rapid City; Craig Schaffer, Frankie Hofer, Butch Rudd, Rapid City Fire Department; Office of Mayor Jerry Munson; Bill and Alice Groethe; and special thanks to editor Peggy Sagen of the *Rapid City Journal* for the loan of additional selected photos from their archives.

—Bev Pechan

INTRODUCTION

This is a book about Rapid City that needed to be compiled for a number of reasons.

First, it is the recording of a period of time that many of us were a part of, and therefore we do not consider it history. But others were not there. Traditionally, children and grandchildren fail to ask those questions about what it was like back then because it does not occur to them that there were days without video games, shopping malls, or television. Many of those youngsters, whom we now call "Baby Boomers," have suddenly realized they don't know much about who they are and where they came from, and so are hitting the internet in droves, trying to link to those genealogy sites in hopes of making some sense of it all.

This book, then, is for you—the generation whose grandparents danced to country swing and rock and roll and competed for ribbons at the county fair in the 1940s and 1950s. And it is for the grandparents who recall that they "had a car like that" and probably drove it to many of the places shown on these pages.

It may be nostalgia, but it is still history.

Rapid City continues to be one of America's most unique cities. It is small by comparison to other cities of importance, but few others can brag of the variety of experiences to be found here. Men who worked on Mount Rushmore are still alive and can share their knowledge firsthand. Bill Groethe has personally photographed most stages of its construction. Rapid City has pioneered in aviation, but it was founded by cattlemen who became wealthy and a few prospectors who did not.

Much of the gold found in and around Rapid City over the years has been that of opportunity. Merchants found needs and filled them. Consumers bought what they needed and scraped together the makings of what they couldn't afford. The history of Rapid City is their history—about how they lived and what they left behind as proof.

Tourism was another goldmine of sorts. Perhaps the richest diggings here are the many schemes and promotions conjured up by those with seemingly impossible ideas, and the belief that people would come by the thousands to see them. Of course, for the most part, it worked.

Then there is the totally awesome outdoors that Rapid City sits right in the middle of: pine trees, aspen, and cottonwood, red earth and bubbling streams. There were no natural lakes, though, so workers of the Civilian Conservation Corps (CCC) and other government programs built Canyon Lake, Pactola Lake, Sheridan Lake near Rapid City, and others, throughout the Black Hills. After the redefining flood of June 9, 1972, Canyon Lake was built for the third time. Bill ironically took no flood pictures because he spent that night rescuing others—one of the rare times he didn't have a camera in hand. Someone you know may have been a part of those important events.

The photographs in this book may show friends, relatives, and neighbors. We hope so. Perhaps you can identify some that we could not. This is how they lived and what they did back then. It was a time past, but not really so very long ago.

Many buildings and landmarks remain. Some have new occupants, some have been altered in some way, some are vacant, and some are still in business. They are all inside and invite your inspection.

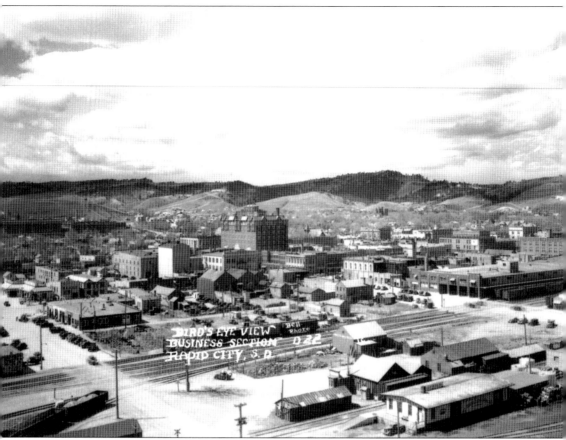

This bird's-eye view of Rapid City was taken from the top of Tri-State Milling Company by Bill Groethe. Here one plainly can see many familiar sights, looking toward Dinosaur Hill on the far right, and south toward the future sight of Rapid City Regional Hospital beyond the Alex Johnson Hotel.

One
NATURAL BEAUTY

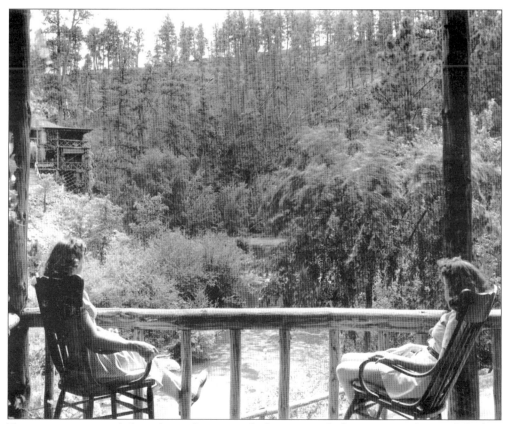

Two attractive young ladies relax and enjoy a refreshing view of tall, pine-scented trees while their companions take a bracing dip in the swift-moving Rapid Creek below Hisega's Triangle I Lodge.

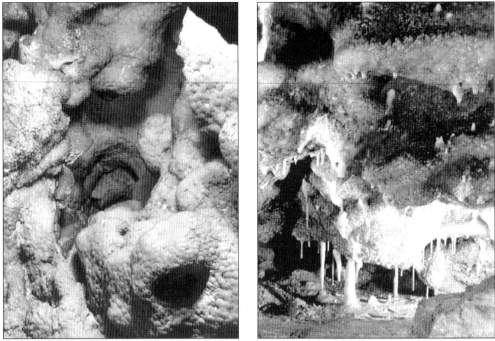

Numerous caves, found within just a few miles of Rapid City, offer varieties of deposits and unusual formations. The Black Hills area has more known crystal caves than any other place in the universe.

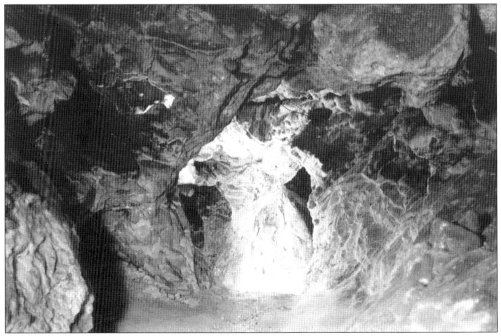

There are those with stalactites and stalagmites and others with lacy box work or popcorn oddities. A subterranean lake, once said to hold blind fish and even an underground waterfall, adds to this below-surface splendor.

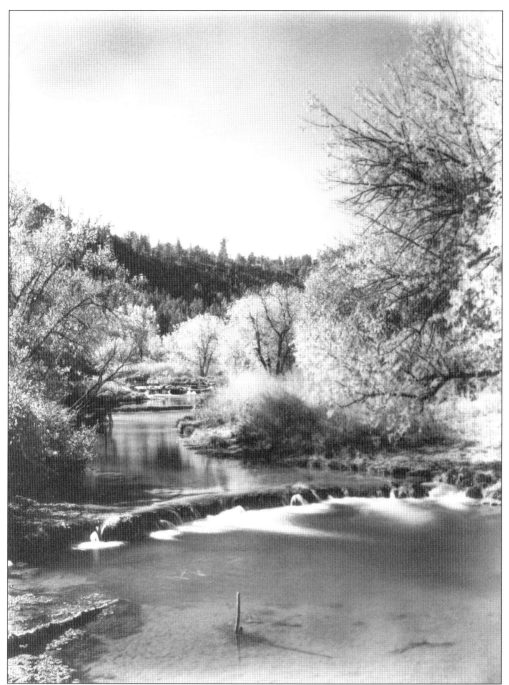

Rapid Creek flows gently through Upper Rapid Canyon's abundant flora. The series of shallow pools shown here are a haven for much-prized Black Hills trout.

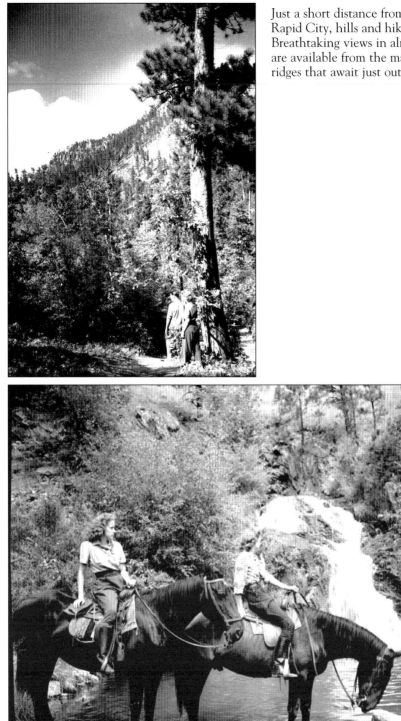

Just a short distance from the center of Rapid City, hills and hiking trails beckon. Breathtaking views in almost any direction are available from the many canyons and ridges that await just outside city limits.

Horseback riding is another way to view the area's natural beauty. These 1940 companions pause to rest their horses near a clear mountain stream before continuing to explore the Black Hills.

Two
GATEWAY TO TOURISM

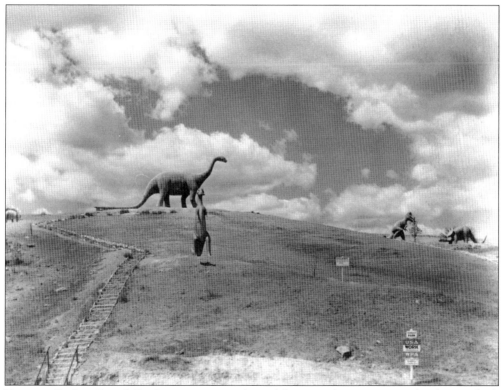

Dinosaur Park at Rapid City's west entrance hosts life-size prehistoric sentinels who overlook the Gap—the hub of early city activity. Below were stage barns for travelers and freighters passing through. Large hay meadows provided feed for livestock. A Works Projects Administration (WPA) project costing $16,067 in 1936, these skyline-silhouetting concrete figures were created by local artisan E.A. Sullivan.

Alex C. Johnson, vice-president of Chicago and Northwestern Railroad, was perhaps the first to see great opportunities for Black Hills tourism in the 1920s. Born in Crawford County, Pennsylvania just before the Civil War, Alex Johnson loved railroads and followed them west, moving to Spink County, Dakota in 1882. He envisioned combined railroad and auto travel in Rapid City that would "surpass the resorts of the world."

Rapid City's landmark Alex Johnson Hotel was completed in 1928 on the site of Eugene Bangs' livery stable at Sixth and Main. Considered the "hotel of the century," and the finest between Minneapolis and Denver, the $500,000 seven-story Alex featured fireproof rooms, elegant dining and dancing, a solarium, and a shopping mall. Designed and constructed by Porte and Whiteson of Chicago, the hotel remains a center of downtown patronage today.

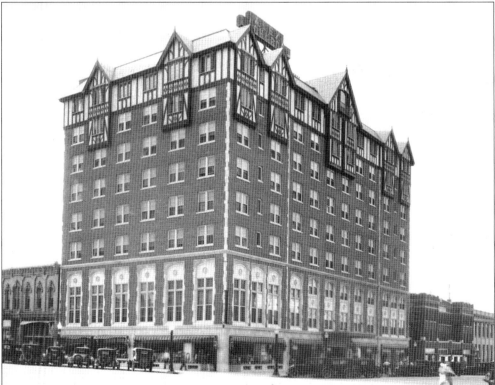

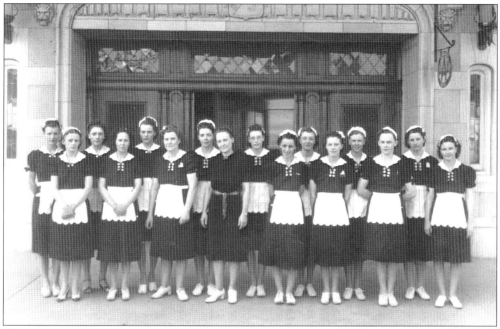

These maids at the Alex Johnson made your stay more comfortable in the 1930s. Rooms ranged from $1.50 to $5.50 per night. Bert DeMerrseman was an early hotel manager. During World War II, there were "juke box" dances and, in the recovery years of the late 1940s, all-you-can-eat buffets in the ballroom for $1.65.

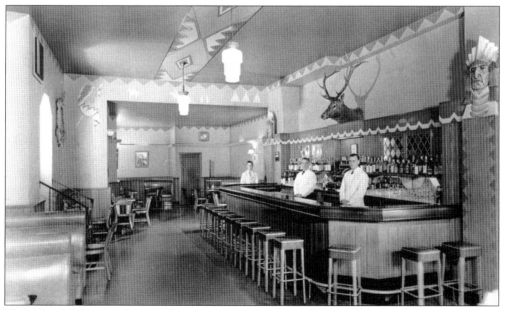

The Alex Johnson's adjoining bar continues an interior theme of Native American and Art Deco influence within a massive Germanic Tudor framework and exterior. The huge fireplace in the hotel's grand lobby was constructed using native fieldstones from the Black Hills. Exposed timbers on the main floor display carvings of Indian chieftains. Patty (Paddy) O'Neill was the hotel's first registered guest and the refurbished bar has been named after him.

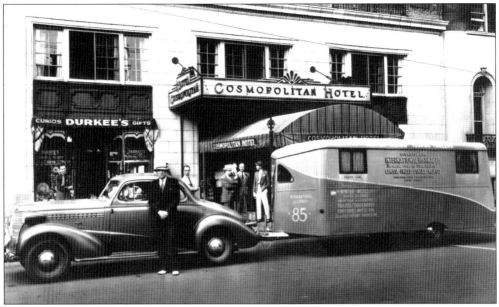

Bert Bell, photographer for the Chicago and Northwestern Railroad, was another promoter who saw tourism potential in the Black Hills. Arriving in Rapid City in 1927, he spent the next decade making post card views of area scenery and Black Hills events. A booster for the U.S. Highway 85 project from Canada to Mexico via the Black Hills, Bell is shown with his travel trailer in Denver.

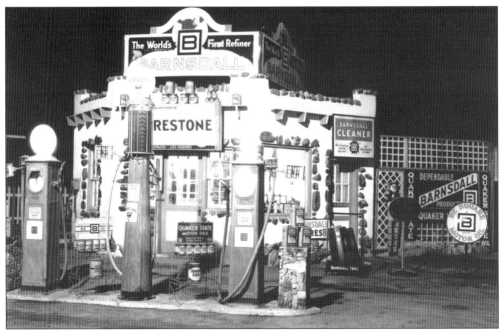

Covered with gaudy native rocks and minerals, this filling station is the ultimate in kitsch. Visitors stopped to fill up and take snapshots for their vacation albums. In 1929, Police Chief Warren Owen counted 72 tourist cars in a 70-minute period passing his headquarters at First and Main. This station, thought to be at 202 Maple in 1937, is long gone, as is the Barnsdall bulk distributor on Third.

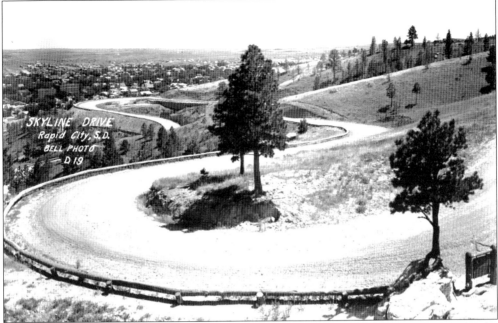

Skyline Drive at the south and west ends of Rapid City was not a motoring adventure for the timid. Riding the crest of the ridge overlooking the city, spectacular views were available in all directions if drivers could take their eyes off the road long enough to look. In 1948, the city made a pact with the county for road maintenance on this valuable tourist attraction.

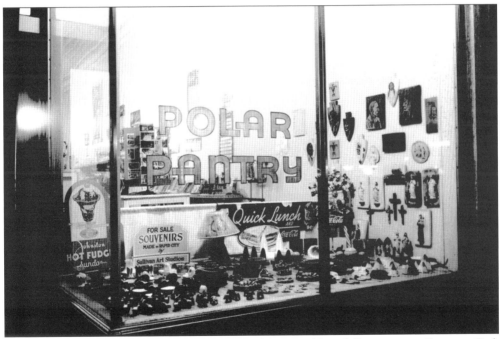

Handcrafted souvenirs were prevalent in the early years of Rapid City tourism. Dinosaur Park creator E.A. Sullivan also mass-produced several novelty items, like these shown in the window of the Polar Pantry ice cream parlor at 628 St. Joe in downtown Rapid City.

Hangman's Hill on Skyline Drive was a popular promontory for picnickers with a sense of the bizarre. This young lady is posing for a publicity shot in 1940. "M" Hill, or Cowboy Hill, is in the distance.

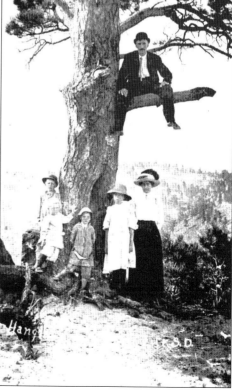

An old postcard view from the early 1900s shows a different tree at Hangman's Hill—possibly the original. In April 1877, the first vigilante hanging in the Black Hills took place here with the execution of three accused horse thieves. One was a lad named Kid Hall, who claimed his innocence to the end.

Plains Indian dolls and intricate beadwork were a part of the original displays at the Sioux Indian Museum in Halley Park. Several important collections were housed there and later transferred to Rapid City's new Journey Museum, along with the historical items of the Minnelusa Pioneer Museum, which shared the building.

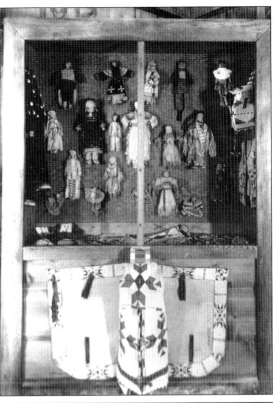

The Sioux Indian Museum and Craft Center on West Boulevard between St. Joe and Main was a popular attraction in Halley Park for tourists who wanted to learn about Native Americans. Under sponsorship of the United States Indian Arts and Crafts Board, the Department of the Interior, and the city of Rapid City, tribal members were encouraged to display and sell their work in the large gift shop.

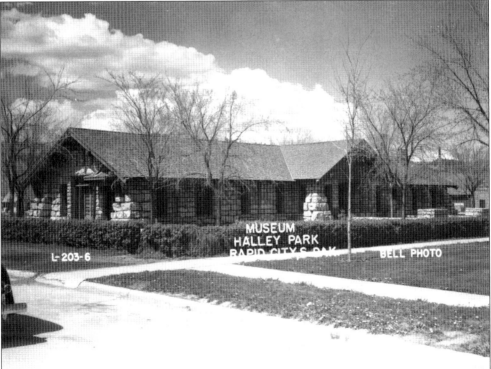

19

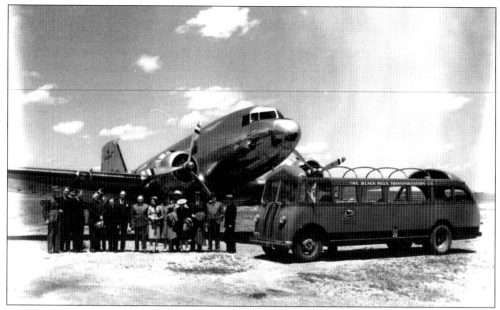

Paul Bellamy, tallest man in the center, was yet another promoter who seldom missed a chance to get something going to attract large numbers of people to the area. Organizing the Black Hills Transportation Company, he provided these unique open-air touring buses for sightseeing jaunts. The United Airlines plane greeted by local dignitaries may be one of the first coast-to-coast flights to arrive in Rapid City.

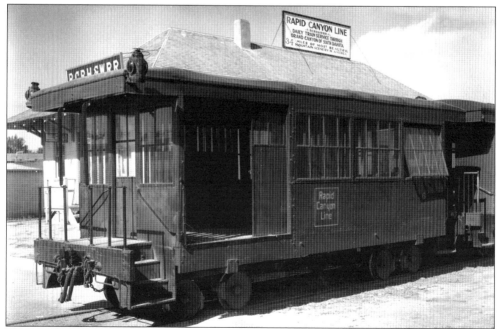

The Rapid City, Black Hills & Western Railroad became known as the "Crouch Line," named for owner C.D. Crouch in 1906. Rapid City later took over the financially-troubled operation, renaming it the Rapid Canyon Line, and ran a daily excursion train through "the Grand Canyon of South Dakota," featuring "34 miles of the most beautiful mountain scenery in America."

Even before it was the Crouch Line, this colorful little train, earlier also known as the Dakota, Wyoming & Missouri River Railroad, served the area, connecting in 1891 with other lines going through mining and logging camps between Rapid City and Mystic. A golden rail was laid at Big Bend with much ceremony in April 1906. These youngsters in the center of the picture are watching passengers arrive at Hisega's Triangle I Lodge in Rapid Canyon.

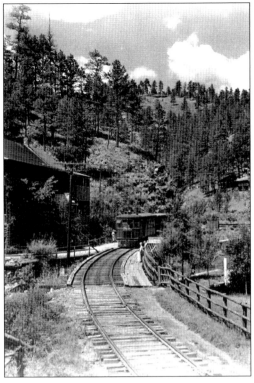

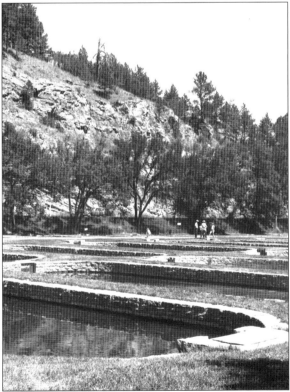

Cleghorn Canyon was first called "Deadman's Gulch" after eight prospectors were murdered in the vicinity in 1876. The Cleghorn Springs Fish Hatchery, shown here, was completed in 1929 for $12,000, with R.L. Ripple as its first superintendent. Two million trout fingerlings hatched annually for distribution into Black Hills streams. In 1942, federal Game, Fish, and Parks workers added 22 new nursery ponds. (Courtesy of *Rapid City Journal*.)

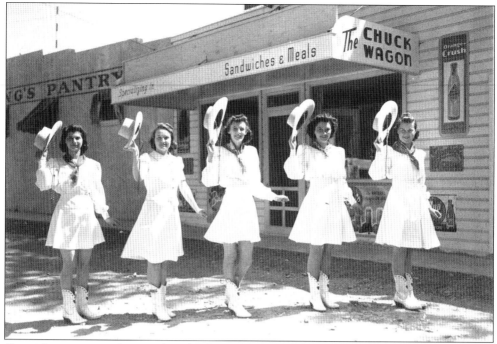

Cowgirl cuties are car hops at the Chuck Wagon diner and drive-in near Baken Park. It opened on Memorial Day of 1940, a house specialty was the country-fried chicken dinner. The waitresses are: Maxine Crane, Hazel Zink, Marian Tidrick, Anna Marie Bornhofer, and Rita Trompeter. "Top hands" were Evelyn McKenzie and Mrs. (?) Tidrick.

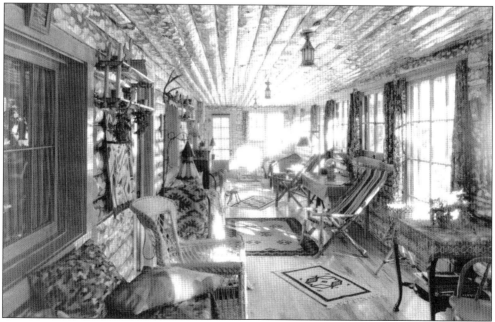

Western hospitality was at its best on this beautifully decorated summer porch of the Ox Yoke Guest Ranch. It was located near the end of the trail leading around Canyon Lake, and the owners were listed as Claude Roth and Richard Walde in 1955.

The Black Hills seemed to have an unlimited supply of colorfully costumed ambassadors who greeted visitors to the area. Princess Paha Sapa, sometimes represented by Mrs. W.D. Cleland and this model, were some of the loveliest six decades ago.

Salesman Warren C. Putnam made the Black Hills his summer home, and on his travels he passed out thousands of "Sunshine Cards" to prospective tourists. The cards listed local events, and he printed them at his own expense. Because of Putnam's unbridled enthusiasm, he was affectionately nicknamed "Everlastingly-at-it-Put." Here he is in his cowboy hat with a friend at the Rimrock Highway Association picnic on September 16, 1956.

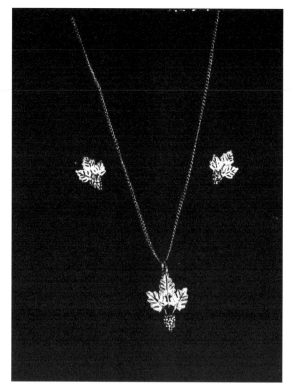

Black Hills Gold jewelry has been a sought-after souvenir since it was first manufactured in 1878. Featuring a traditional grape and vine motif in tri-color gold of red, green, and yellow; rosy red is obtained by adding copper, and green takes its color from silver alloy. Since the 1980s, gem stones and diamonds have sometimes been added to follow current trends.

This photo, taken in October of 1937 at the Black Hills Jewelry Company, shows workers at various stages of creating colorful Black Hills Gold wares. "Every article—on average—is handled at least 50 times before the product is finished," read early promotional literature. Ivan Landstrom, who was handicapped, is said to have employed many handicapped workers in the little factory at the rear of the retail store on St. Joe.

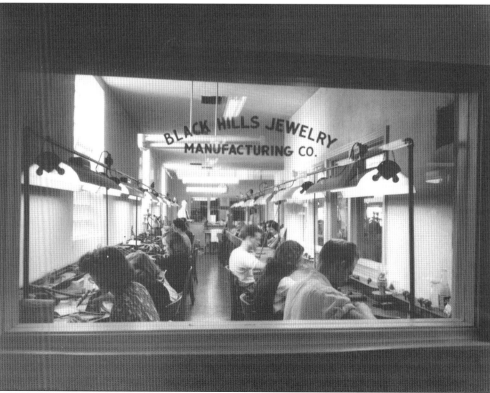

Earl Brockelsby is shown here milking a rattlesnake. In 1950, Reptile Gardens had 35 employees and tallied 250,000 visitors, making it one of the most popular stops in the Black Hills. In the 1940s, Brockelsby offered to buy all snakes, paying one dollar per pound. Ads claimed: "1,000 live reptiles from all over the world on display." When four-lane U.S. Highway 16 was constructed, Reptile Gardens was moved closer to that location.

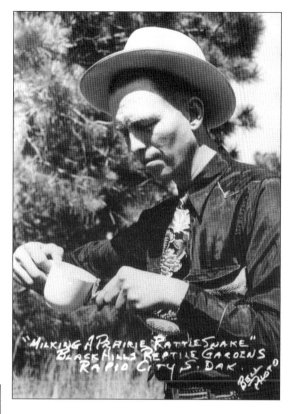

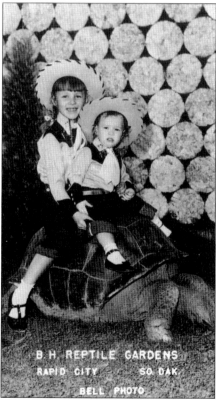

Methuselah, the giant Galapagos tortoise born around 1881,has given rides to thousands of youngsters at Reptile Gardens. The original Reptile Gardens building atop Skyline Drive opened for business in 1937. Its unusual facade contained 48 varieties of Black Hills minerals. Purposely situated at the summit, the gardens were visited by tourists who gladly parked their overheated cars to see what was inside the attraction.

Baken Park Tourist Camp at the west end of Rapid City was managed by Sam Baldwin, beginning around 1926. The popular outdoor dance pavilion had Wednesday and Saturday dances featuring bands like Sam and his City Fellers from station KFYR in Bismarck, North Dakota, and young Lawrence Welk, who played there June 4 and 5, 1942. During the 1950s, the Black Hills Playhouse company also performed there.

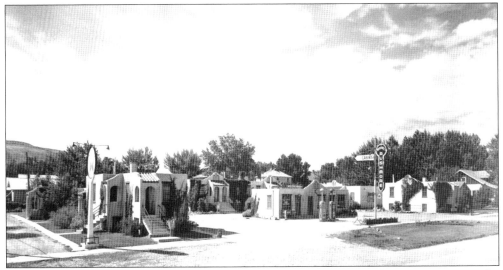

This attractive Spanish-styled motor court with its tile roofs and adobe-looking stucco was the Rushmore Motel. In 1941, it was listed at 207 St. Joe with Mr. and Mrs. Earl Updike as proprietors. Early in 1948, the motel offered "reasonable rates by week or by day" and "telephones in every room."

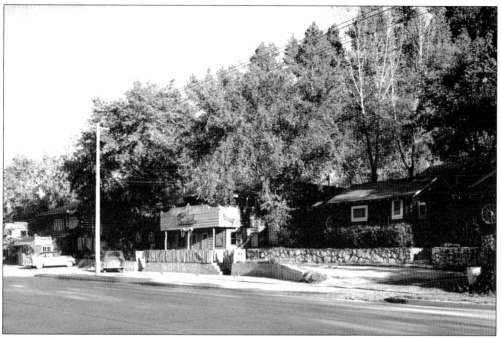

At the other end of town, Ricki's Motel at 1609 St. Joe near Baken Park was nestled in the trees and gave a rustic appearance. In 1955, it was operated by Milo and Bing Harrington. The main building remains today and is a scuba supply dealership.

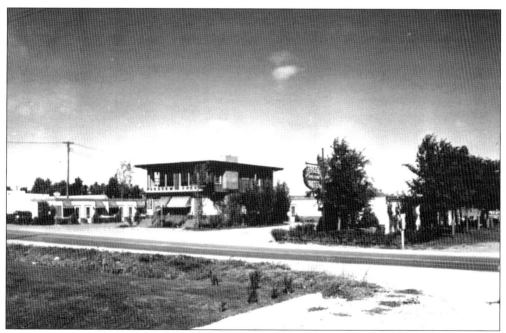

Jensen's Pine View Motel at 1916 South Eighth took on several new looks over the years. Ralph and Alice Jensen were ideally situated on the little two-lane road to Mount Rushmore, which was also U.S. Highway 16. The route was widened to four lanes and renamed Mount Rushmore Road in 1959, due to the efforts of another motel owner, Marvin Beach.

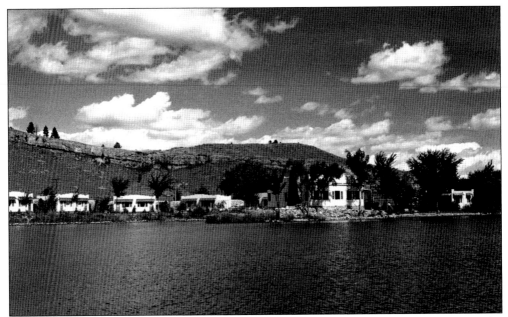

Nystrom's secluded and restful resort on Canyon Lake, which was out in the country in the 1940s and 1950s, sat right on the waterfront. Canyon Lake Drive, formerly called Indian School Road, ended at the municipal park. Nystrom's was near the end of the narrow road just beyond Canyon Lake Tavern, Castle Drive-Inn, and the city pumping station.

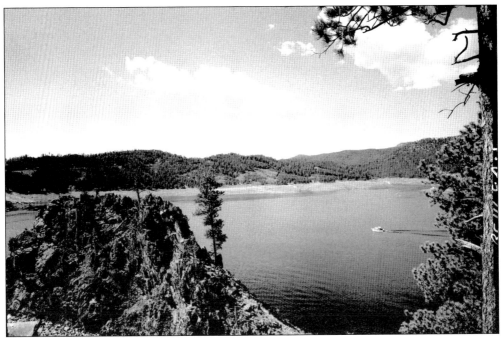

Pactola Lake and the dam on U.S. Highway 385 above Rapid City, which served as the source of Rapid City's water supply and county irrigation systems, were completed in 1956, creating a spectacular deep water lake and reservoir that are still extremely popular with boaters and water skiers. The historic little village of Pactola lies submerged far beneath its surface.

Three
LOCAL COLOR AND PROMOTIONS

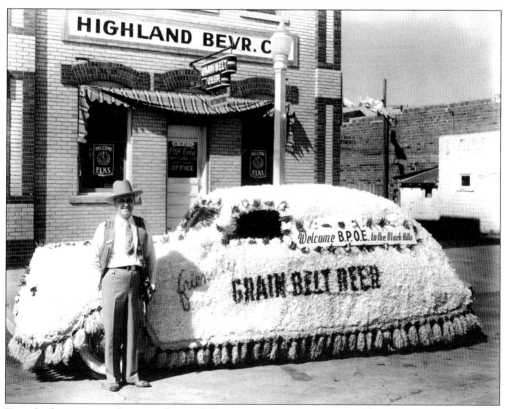

Everybody got into the act when celebrations came to town. Highland Beverage Company decorated their fleet of cars and trucks as part of an elaborate parade welcoming Elks to Rapid City's B.P.O.E. 1187 convention over 60 years ago. Pictured with the fluffy car is Highland Beverage owner, Al Costello, at 822 Main.

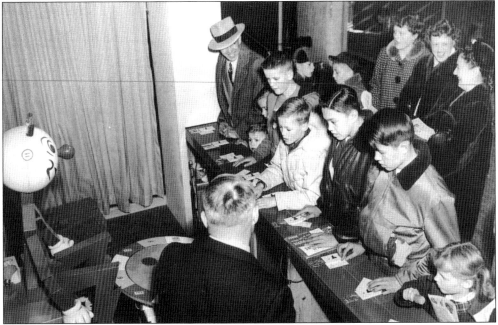

Youngsters on a field trip take part in an electrical experiment under the watchful eye of industry mascot Reddy Kilowatt during the Jaycee Merchandise Fair, which was held at the city auditorium on February 27 and 28, 1948.

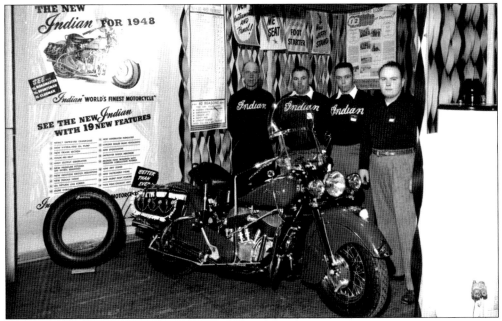

The Jaycee Merchandise Fair was billed as "South Dakota's No.1 Market" in 1948. Indian motorcycle dealers proudly show off the latest in chrome pipes and leather saddlebags. At far left is J.C. "Pappy" Hoel, founder of the Jackpine Gypsies motorcycle club and the famed Sturgis motorcycle rally. Second from the right is Earl or Lloyd Atwater. In the 1950s, Roger Saterlee ran Rushmore Motorcycle Sales on East North Street.

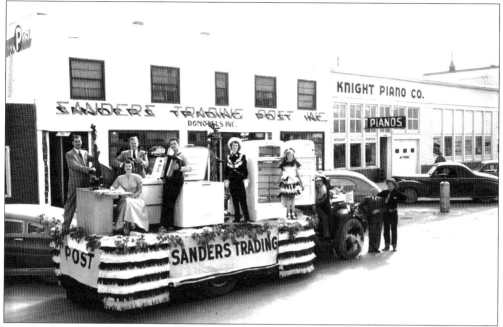

Ray Sanders, in the big hat, far right, stands in front of the Sanders Trading Post float and store at 417 St. Joe in 1953. Sanders and his wife kept folks guessing for years about their Hidden City lost civilization "discovery" located between Rapid City and Hermosa.

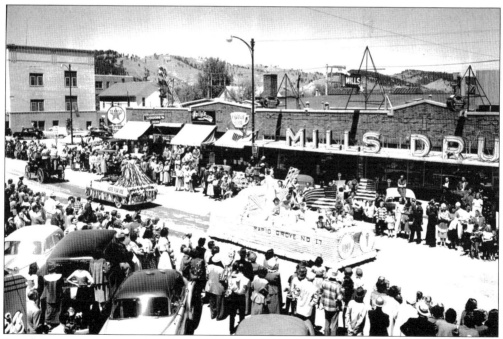

Rapid Citians have always loved to celebrate, and parades seem an ideal way to do it. In 1951, the city's 75th Anniversary Diamond Jubilee did not go unnoticed. This is the Department of Transportation's gala parade in June 1952. Since it was also a presidential election year, the theme was colorfully patriotic.

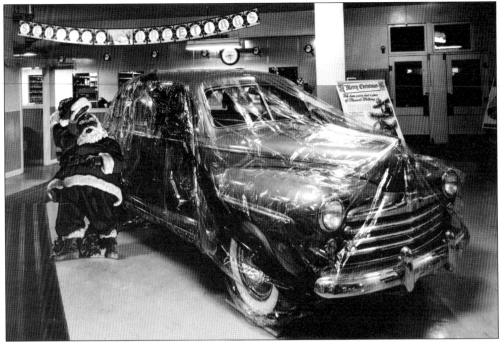

Christmas in 1947 shows Santa and a brand new Ford family sedan all cellophane-wrapped for gift-giving. It even had extra-wide white sidewall tires. No new cars were produced during WW II, and old ones had to be fixed. McCluskey Ford claimed their repair crew of Lee Barton, Bill Mass, Manley Juide, Henry Dahn, John Bush, Carl Bittermeier, Gus Mallow, and Virgil Haugh had "113 years of experience."

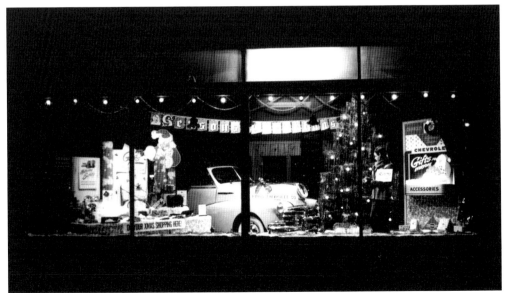

By Christmas of 1948, auto dealers like Rapid Chevrolet had figured out ways to enhance the holiday shopping season by offering eye-catching displays that included merchandise loaned by other local merchants. These festive Christmas windows at participating dealerships were enjoyed immensely by the public, who drove around the city to view them.

"Dakota Clyde" Jones was a true cowboy who won many rodeo contests riding bucking broncos and wrestling ornery steers. A soft-spoken man, Jones was chosen to guide President Calvin Coolidge around the Black Hills during his stay here in 1927 and taught him to ride a horse. Jones lived in a cabin at the Stratobowl.

The sign on Bernice Musekamp's cabin at Pactola offers pies for sale as she waits for a customer in the late 1920s. Bernice, always a colorful character, later ran her Moosecamp Lodge on Highway 85A that featured Sunday fried chicken dinners, roast elk, buffalo, and of course, her famous pies. (We and others think this must be Bernice in the photo, though a few disagree.)

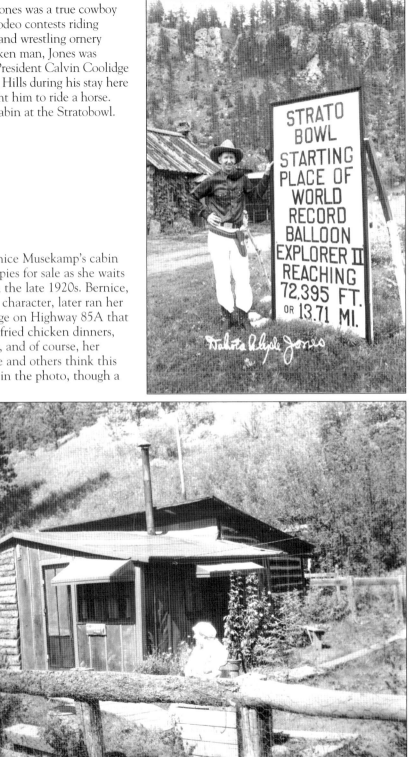

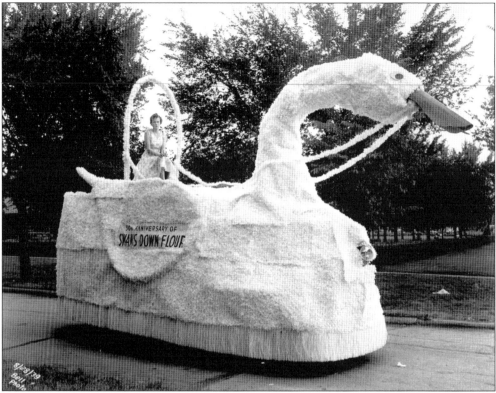

Waiting for the parade to start, a lovely queen perches high atop the Swan's Down Flour float at Halley Park for a downtown celebration in 1939.

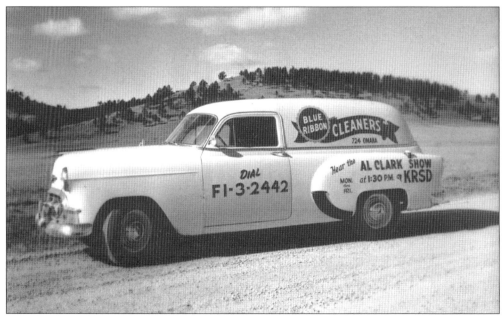

Advertising is at its best as a moving billboard. This Blue Ribbon Cleaners panel truck is reminding listeners to tune in to the Al Clark radio show on KRSD in early March of 1956.

These sweethearts are waiting to serve you at Donaldson's brand new candy department just before Valentine's Day in February of 1948. Delicious candy has always been considered one of the area's major food groups. Rapid City's newest downtown department store replaced the Minneapolis-based Golden Rule store built here in 1929. Manager Lou Haggerty resigned in 1954 to start his own retail operation.

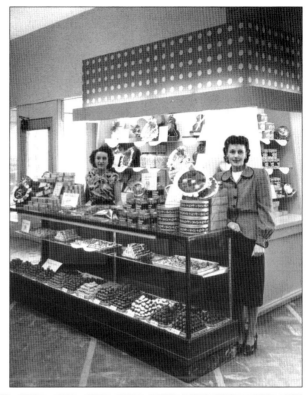

Montana-Dakota Utilities sponsored its popular cooking show, "The Blue Flame Kitchen," which starred Rosemary Anselmi, over KOTA television. Post-war years saw the beginning of the "baby boomer" era, as new and enthusiastic young homemakers sought smart, economical, and innovative ways of cooking and entertaining. This photo was taken on October 29, 1956.

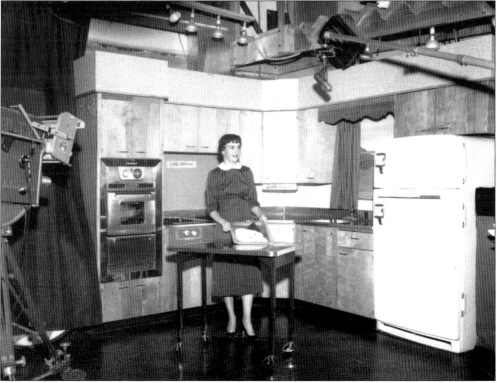

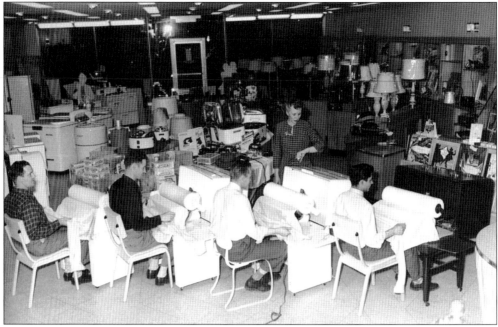

Men aren't often conned into doing housework, but the competition of this timed event must have proved to be a challenge worth the effort. Perhaps a prize? The mangle ironing contest was an event held during Black Hills Power and Light Company's retail store grand opening, possibly in the early 1950s.

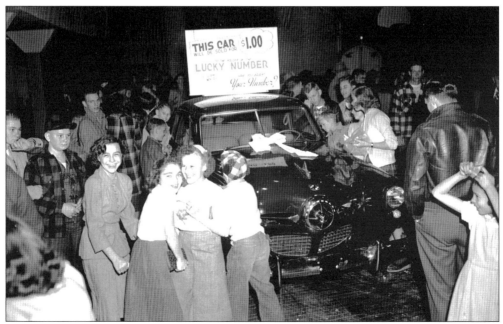

And who wouldn't take a chance on a new Studebaker for only one dollar? Motor Service Company and Ed Morrison at 404 St. Joe concocted this idea to get people into the showroom on November 22, 1949. Hundreds hoped to be the winner of this bullet-nosed beauty. Enough ticket sales would pay for the car and perhaps sell others to non-winners.

Four
PEOPLE AND
CIVIC AFFAIRS

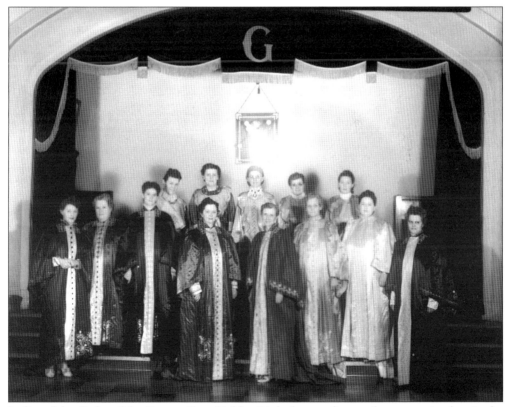

Ladies of the Order of the Eastern Star, Golden Link chapter, line up for a portrait taken in the 1930s or early 1940s. Masonic involvement has been a part of social life here since Rapid City's 19th century beginnings. In 1929, Rapid City Lodge #25, some 200 strong, voted to build "a $40,000 home in the near future." It is located at 618 Kansas City.

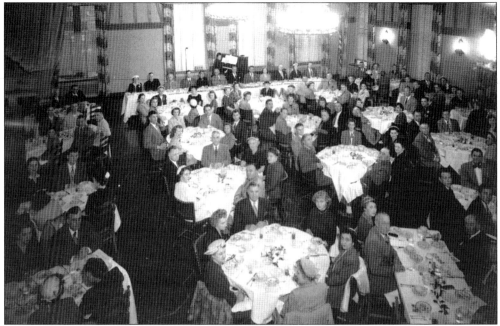

Members and guests of the Y.W.C.A. and Y.M.C.A. gather for a banquet at the Alex Johnson Hotel on April 15, 1952. In 1948, a national charter was issued for the recently formed Y.M.C.A. chapter in Rapid City, Don Knecht, chairman. This was followed by a merging of both groups and the Jaycee-sponsored Cactus Patch. City fathers welcomed the new organization and their contribution to community youth services.

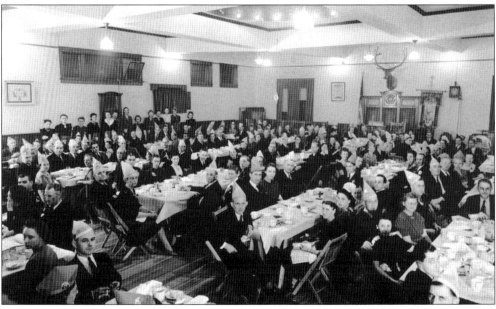

Elks Lodge B.P.O.E. #1187 celebrates at a banquet on the top floor of the Elks building, located at Sixth and Main. Local businessman Francis "Bud" Duhamel is pictured at center left. The Elks sponsored Trout Day at Canyon Lake Municipal Park with a fishy feast for 3,000 attendees in 1929. The date of this photo is March 9, 1943.

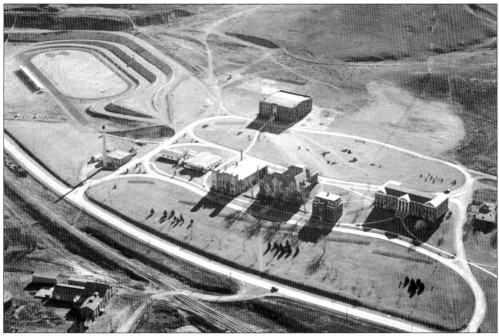

A bird's-eye view of South Dakota School of Mines campus is shown here. Its first buildings were constructed in the 1880s. The National Smelting Company built an ore smelter nearby in 1901, the gymnasium was added in 1928, and in 1938, O'Harra Field, named for past president Dr. Cleophas C. O'Harra, was dedicated. O'Harra Field, still much in use, was originally a hog farm site surrounded by frog ponds.

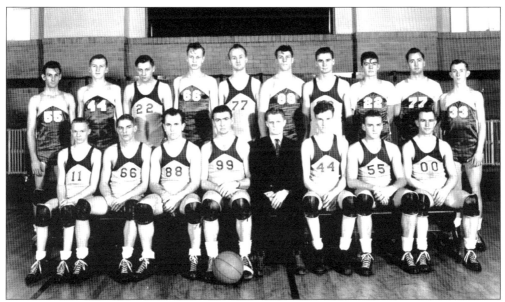

Dr. Harold B. Goodell, School of Mines athletic director, center, sits for a Hardrockers team photo in January 1946. The college gymnasium is named for him. One of the state's oldest radio stations, WCAT, aired Associated Press news, sports, and editorial views from the second floor of the gymnasium building.

Pennington County Superintendent of Schools Amos Groethe was born to Norwegian-born parents in 1881 and joined the Rapid City school district in 1912 as a teacher. He later became principal, and eventually city (and then county) superintendent. His administrative job took him to many rural schools where he encouraged learning among youngsters by devising inter-school competitions. He left education briefly, and after serving two terms as city auditor, was again county superintendent, finally retiring at age 88.

Rapid City High School was an imposing sight when completed in 1928. Built in part with Public Works Administration funds, the four-story brick building at 615 Columbus boasted state-of-the-art everything. During President Calvin Coolidge's stay in 1927, Amos Groethe's office in the old high school building, right, was used as a base of communications. From here, Coolidge bluntly announced: "I do not choose to run."

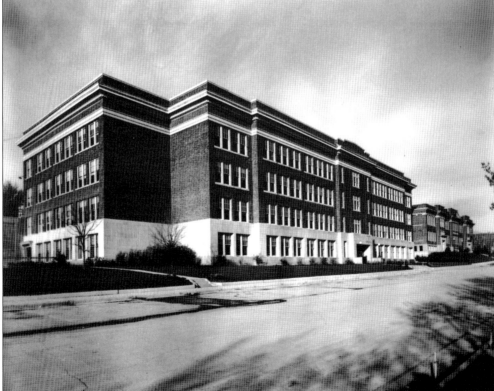

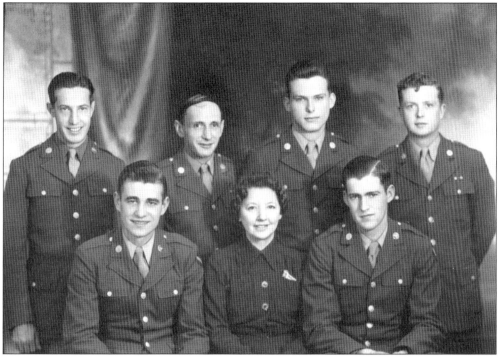

Daurel Bell, wife of Bert Bell, was an accomplished and innovative photographer herself. She ran Bell Studio during the WW II years, pioneering the "Hollywood" lighting technique in glamour poses. Local studios were so busy during this period that lines sometimes formed outside, and doors had to be locked at intervals to allow time for printing orders. Daurel befriended many servicemen, who affectionately called her "Ma Bell."

Ned Perrigoue was a young cowboy of 14 when Bert and Daurel Bell took him in. Bert Bell, for a time, managed the famed Flying V ranch near Newcastle, Wyoming. Perrigue learned photography, capturing several stages of Mount Rushmore construction for Bell Studio, aided by Bill Groethe. He entered the Navy as a cinematographer and also filmed newsreels for Fox Movietone and Pathe news that were shown in theatres.

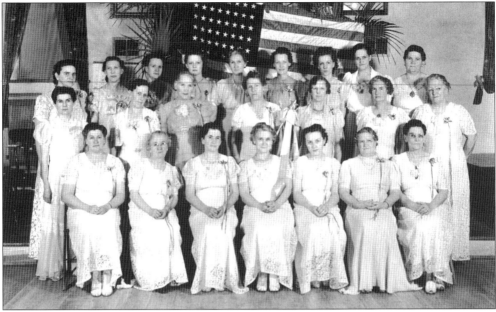

The Rebekahs gather among potted palms and a 48-star flag for this early photo. The only person positively identified is Edith Mellgren, at the far left in the first row.

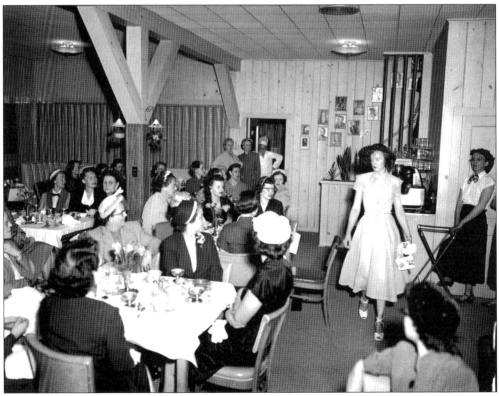

This chic luncheon-style show took place nearly a half century ago in Toscano's restaurant. It was sponsored by the ladies of Beta Sigma Phi, Alpha Mu chapter, on March 26, 1953.

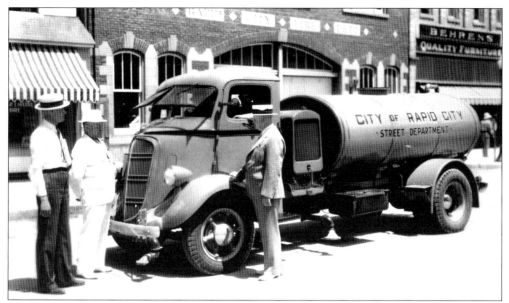

Rapid City's new city water truck was a Studebaker, appearing to be from the late 1930s. The Rapid City Fire Department building, now Firehouse Brewing Company at 610 Main, is in the background, and Behren's Furniture Company is at the far right. Though we can't positively identify the men in this picture of 1941, William Cabot was street and alley superintendent and Swaney Swanson was in charge of water and sewer.

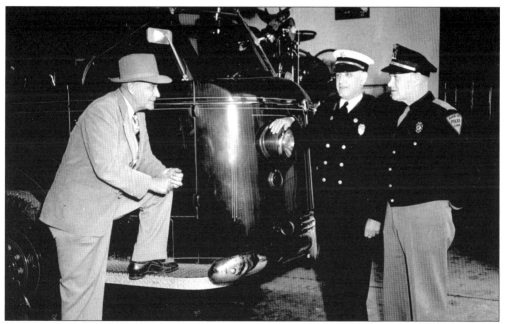

Fire chief George Engler and police chief Louis Nordbye examine their new American LaFrance fire engine. Number Five was the city's first aerial ladder truck. The man on the left is probably mayor Montford "Bud" Wasser. City Treasurer Irwin Leedy collected $50,000 in dimes and nickels from Rapid City's parking meters during their first year of operation, beginning in 1947, which may have helped purchase the truck.

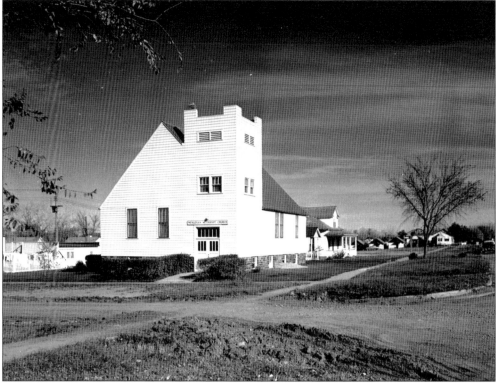

The Weslyan Methodist Church at First and Kansas City streets appears to be out in the country in this May 15, 1951 photo. The Reverend Gordon W. Goodsell officiated as pastor back then.

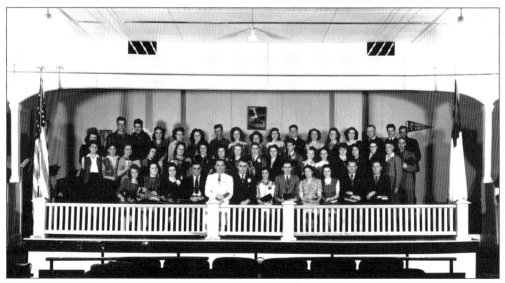

In 1942, the Assembly of God Tabernacle at Eighth and Quincy held revival meetings nightly—except on Saturdays. In May 1951, Pastor Bernard Ridings announced that the church would auction off "24 choice home sites" on church property near Canyon Lake in the former Schamber addition. Bordered by Jackson Boulevard and 32nd Street, Rapid Creek meandered through the area. Auctioneers were Col. C.C. Rinehart and Francis Haley.

Considered "one of the most modern church buildings in the nation" at its December 14, 1947 dedication, the Harold Spitznagel-designed Trinity Lutheran Church at Fourth and Kansas City cost $167,000—paid for with donations collected over a decade. While local contractor Henry Hackett was erecting the elegant brick structure that featured an 84-foot tall tower and cross, happy parishioners worshipped in its basement.

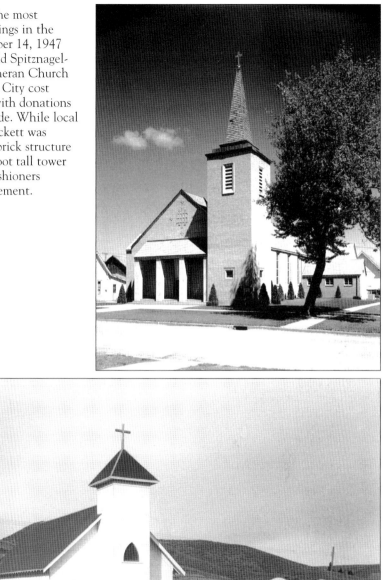

By moving this tiny building into the Canyon Lake community, a facelift and paint gave life to Rapid City's newest Catholic church. Blessed Sacrament Catholic Church was also dedicated on December 14, 1947. The mass given by Bishop William T. McCarty compared the analogy of St. John the Baptist to that of Father Bernard A. Drew's missionary efforts in recruiting a church home for the little neighborhood "in the wilderness."

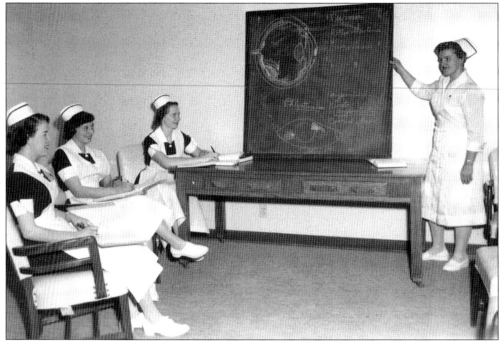

An accredited nursing school was a part of St. John's McNamara Hospital, run by the Benedictine Sisters of Sturgis. The nurses' dormitory and facility was located adjacent to the hospital at 1014 11th Street. These nurses at Bennett Hospital are continuing their studies by learning about tumors in the early 1950s.

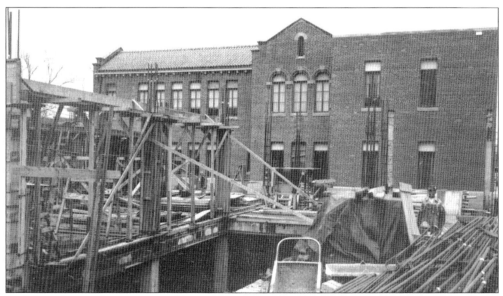

St. John's Hospital got a new addition in 1951, constructed by M.A. Garland Company. In 1953, Brezina Construction Company expanded the facility again with a multi-story wing. The first St. John's Hospital was a white frame structure across from Halley Park, established in 1926. The permanent site was purchased in 1927, and a brick building was erected the next year, a gift from the McNamara family.

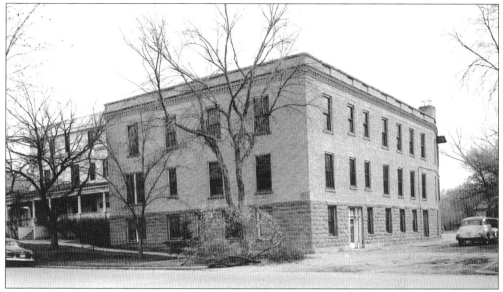

Black Hills General was the city's other early health care facility at 803 South Street. Just before Christmas in 1948, nurses took turns sitting on bank corners in all weather, soliciting pledges and donations and calling attention to the need for a new hospital. Bennett Memorial Hospital was built at Mountain View and Canyon Lake Drive in 1951. Rapid City Regional Hospital was established in 1976.

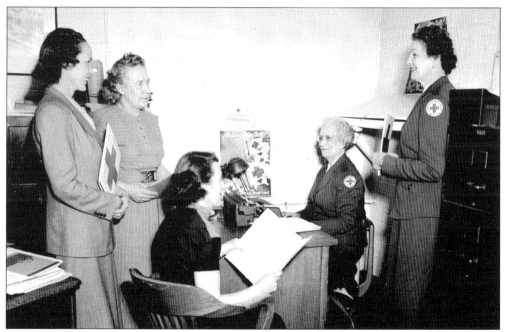

The donors pictured here sign pledges for the American Red Cross in 1953. The Korean War was another one of the tragedies requiring a steady stream of blood donors. The certificate on the wall is honoring the Pennington County Red Cross chapter for meritorious service. In 1951, Mrs. T.A. Crikac was chairman and Grace Wethe was executive secretary. Offices were at 713 Seventh Street. Lou Loocke may be the woman behind the desk.

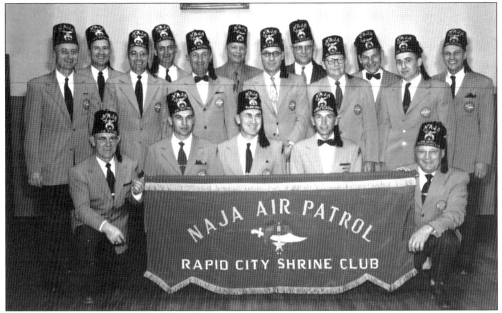

Members of the Naja Shrine Air Patrol proudly pose with their banner in this May 18, 1955 photo. The air patrol was organized by Pennington County Sheriff Glenn Best, shown second from left, front row. Much of the flying done by these dedicated pilots involved the airlifting of critically sick and injured children to specialized treatment centers across the nation.

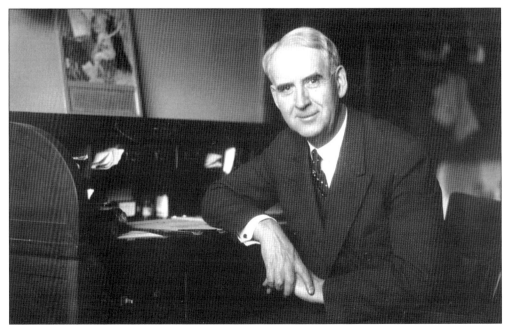

Dr. R.J. Jackson, "Mr. Rapid City," was a physician, surgeon, and entrepreneur as well. He dabbled in real estate, farming, tourism, and public office after his arrival here in 1902, and was for a time the only doctor in town. He promoted Strathavon, an early housing project concept, and donated the land for Canyon Lake Park. Jackson Boulevard is named for him. (Courtesy of *Rapid City Journal*.)

When Bishop John J. Lawler came to the Black Hills in 1916, he found only 16 priests serving 42,000 square miles. The diocese moved to Rapid City from Lead in 1930, and by the time of Bishop Lawler's death at age 85 in 1948, he had installed 107 priests in 87 parishes. Subsequently, 267 churches, 87 rectories, 10 schools, 11 convents, 2 hospitals, and a school of nursing were built.

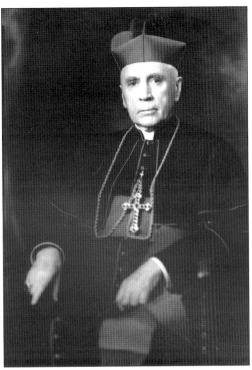

Immaculate Conception students form an honor guard for church dignitaries at the installation of Bishop William T. McCarty as co-adjutor of the Rapid City Catholic diocese on May 8, 1947. Bishop Lawler, the oldest living bishop in America, was in poor health, forcing him to relinquish his duties. Leading the delegation of Ogallala Sioux attending the ceremonies were chiefs Iron Cloud and Sam Stabber and their families.

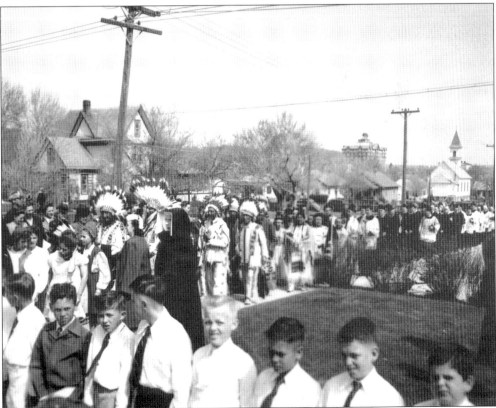

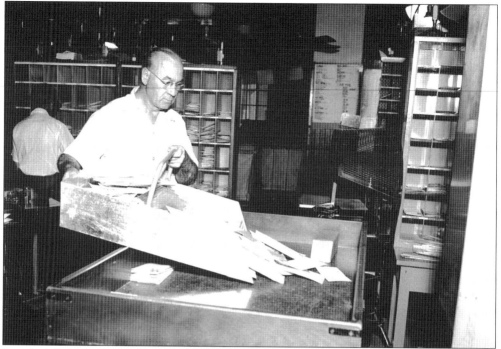

Postal worker Marvin Keck sorts mail the old way in this September 9, 1955 photo. The main post office at Eighth and St. Joe is an office building now, but in 1947, the station installed the first pre-cancelled postal meter in the West River area, doubling its efficiency. In December of 1947, postmaster E.L. Bangs reported revenue for that month totaling $32,562.

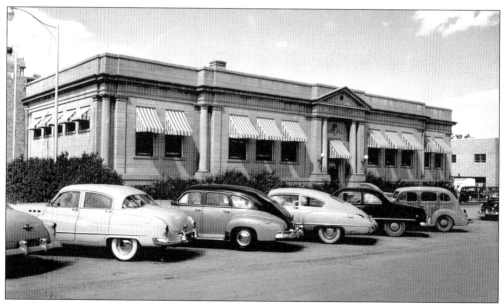

Rapid City's Public Library at 604 Kansas City was considered very modern when it was built in 1919. Several large expansions to the metropolitan library system have taken place since this 1950s photo was taken. When the present location of 610 Quincy was selected for a new building two decades later, the old library became Rapid City's "new" police station.

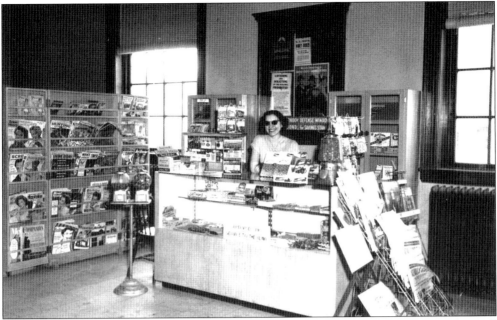

The news stand and snack shop at the Pennington County Court House was and is still sponsored by organizations helping blind persons. Freddie Campbell was the personable young woman who waited on customers 50 years ago.

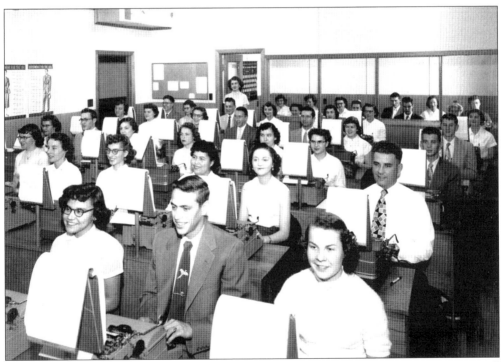

National Business College, located across from the court house at 324 St. Joe, offered G.I. Bill training to returning veterans and other young men, and to women wanting to get ahead in office skills for better jobs in the 1940s and 1950s. The school's director was Clarence Jacobson.

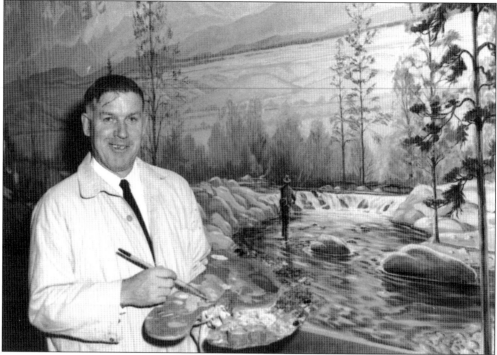

Artist Bernard P. Thomas of Sheridan, Wyoming puts the finishing touches on his 80-foot-long Irish linen mural installed in the Rapid City National Bank in 1960. Thomas was also the creator of the acclaimed "Cyclorama"—a detailed 180-foot oil-on-canvas panorama depicting America's heritage, which dominates its gallery room in the Dahl Fine Arts Center.

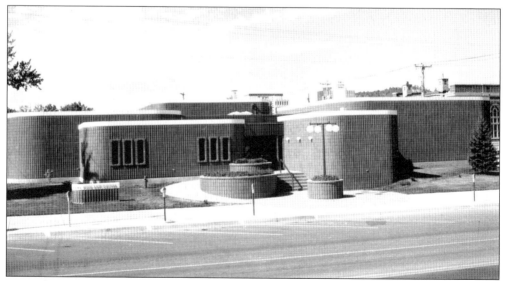

Located at 713 Seventh Street, the Dahl Fine Arts Center was a gift to the city from Mr. and Mrs. Arndt E. Dahl in 1973, with Rapid City agreeing to pay maintenance costs in perpetuity. The Cyclorama, completed in 1975, is here, and works of regional artists are displayed year-round. The Black Hills Community Theatre and musical groups perform regularly on the Center Stage.

Five

NEIGHBORHOODS

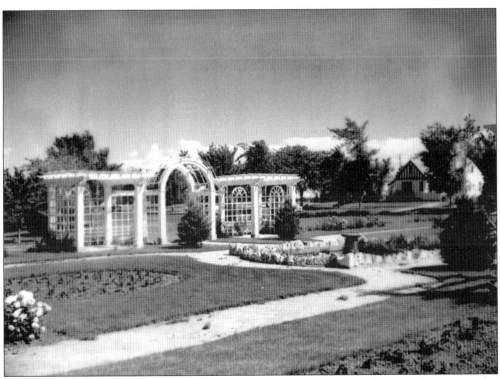

This graceful pergola at Wilson Park adds to the charm of Rapid City's quiet places. Founded in 1940, Wilson Park is situated along Mount Rushmore Road on Rapid City's south side. City parks and schools were frequently named for American presidents during the construction of Mount Rushmore from 1927 through 1941. Spectacular summer arts festivals are held here every June.

Mrs. Adolph (Matilda) Stoltz poses next to the diploma licensing her as a masseuse and physiotherapist in March, 1952. Mr. Stoltz and son, Ray, managed the Coast-to-Coast franchise in Rapid City.

This is Boy Scout Troop No. 51 from Horace Mann Elementary School at 902 Anamosa Street in North Rapid. The group's troop leader was Joe Burke when this photo was taken on February 3, 1956.

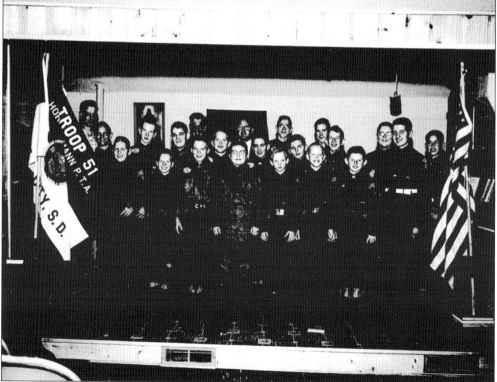

East Boulevard Park was a shady oasis with its rustic entrance off East Boulevard and Main, occupying the area now housing Rapid City's fire department, old administration building, and automobile sales lots. Said to be a pet project of local activist "Ma" Brown, the park was not rebuilt after the 1972 flood.

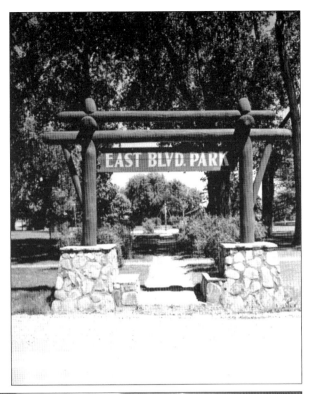

Rapid City Air Force Base, also called Weaver, and later, Ellsworth Air Force Base, has always had a family-oriented population nearly half that of neighboring Rapid City. Base housing projects and amenities included shopping, schools, and this new swimming pool, completed in mid-August 1955.

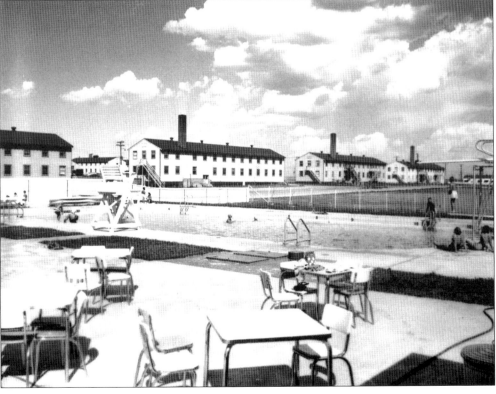

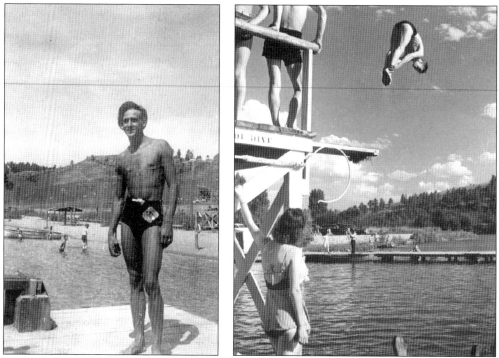

Carl Loock, above left, was the senior municipal lifeguard at Canyon Lake and did much to promote water sports of all kinds. The extended Loock family has since produced several world-class diving champions. Bill Groethe, above right, won the boys' free style race in 1934 at age 12. Here he is executing top form in a high dive from the tower in 1940.

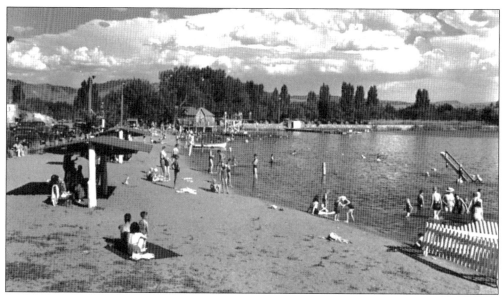

Beginning in 1934, Carl Loock promoted local swim meets "to acquaint the public with Canyon Lake Beach and the work that is being done to make swimming a safe and interesting sport for Rapid City people." Hot summer vacations when school was out meant long days spent at the beach, Bill Groethe recalled, because, back then, there were few other youth opportunities.

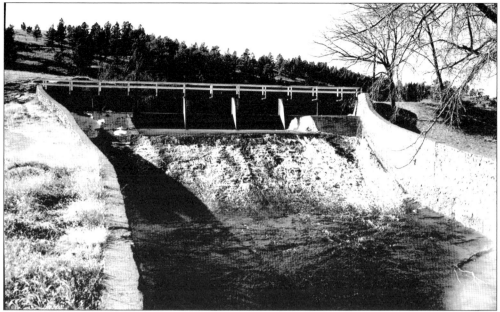

Canyon Lake spillway and dam in Canyon Lake Park has always been a popular spot for hiking, cycling, and walking the family dog. An earlier dam in another location was made of logs, and the one shown here gave way during Rapid City's disastrous flood on June 9, 1972. A larger dam replaces it now, and is still a great place to be on a sweltering summer's day.

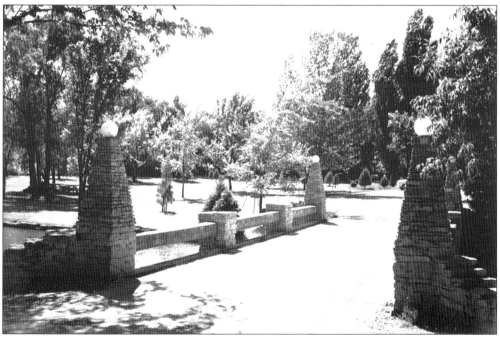

Stately, tree-shaded Canyon Lake Park along Jackson Boulevard sported this modern entrance a half century ago. Canyon Lake Boulevard, skirting the western edge of Rapid City, leads directly to the park with its pavilions, picnic tables, and playground equipment. Next door is Meadowbrook, the city's largest public golf course.

One of Rapid City's first neighborhoods was the elegant Victorian and neo-classical West Boulevard District, now a registered historical landmark. Consisting of 133 homes, most residences were built before 1920, encompassing portions of 18 city blocks. This 1940 contemporary executive "model home" was built at the south end of the boulevard and raffled off to raise funds in support of an area hospital for polio victims.

Hobart Funeral Home at 919 Kansas City provided 24-hour ambulance service, two-way radios, and oxygen as part of their service to the community. The art deco viewing chapel was the final act of caring provided by Mr. and Mrs. Don Hobart. This photo dates to 1954.

Lattice framework sets off the WW II Veteran's Memorial in Halley Park downtown. The lovely rose gardens surround the bronze tablets containing names of area servicemen. In 1940, city parks superintendent Leslie Kiel, in cooperation with the Cosmopolitan Club, was available to give home gardeners tips on raising their own prize roses.

Several parks lie in and around Rapid City, each giving a special flavor to its neighborhood. Here, tennis courts at Sioux Park on the city's west side beckon. Extremely mild January warm-ups prompted winter tennis meets referred to as "the Banana Belt Open." Centrally-located Roosevelt Park got a new swimming pool in the summer of 1951, courtesy of the Kiwanis Club, and Signal Hill had Neptune Pool.

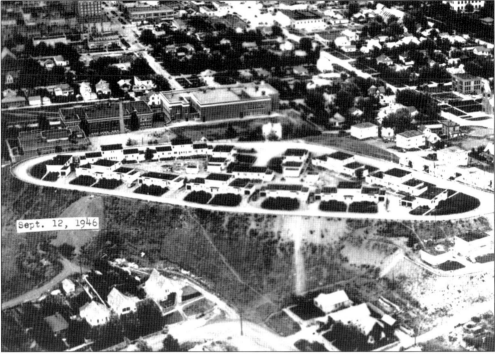

Sept. 12, 1946

Now you see it. This is Paul Bellamy's Hillcrest Terrace housing project overlooking Rapid City in 1946. These modern rentals were to help alleviate the housing shortage that occurred following WW II. Price ceilings were in place to ensure that costs would remain affordable. City officials received 700 requests for housing that year and were able to fill less than half.

Now you don't. In the spring of 1947, much of Hillcrest Terrace, built on slippery shale, slid to the bottom of the hill and onto the streets. Bellamy was sued in federal court the following year for raising fees above the limits to compensate for the "hardship" of his loss. He was allowed a "flat increase of $10 per unit per month" on surviving apartments. A few remain today.

Known as Eighth Street in this April 1949 view, this was the main road leading out of town to Mount Rushmore. To the left is Hermanson's grocery store near the intersection of St. Cloud Street. Renamed Mount Rushmore Road, Eighth Street was paved and widened to four lanes in 1959 to accommodate increased tourist traffic.

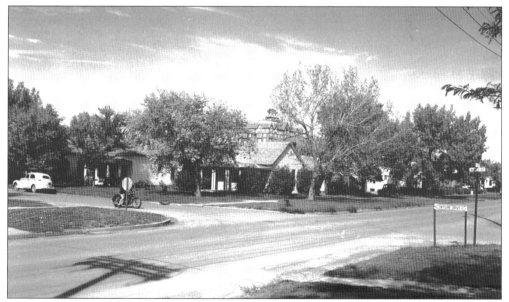

Pointing the way to Dinosaur Park, the sign on West Quincy is the only indication of any activity taking place in this sleepy and serene residential section of town between bustling Eighth Street and West Boulevard.

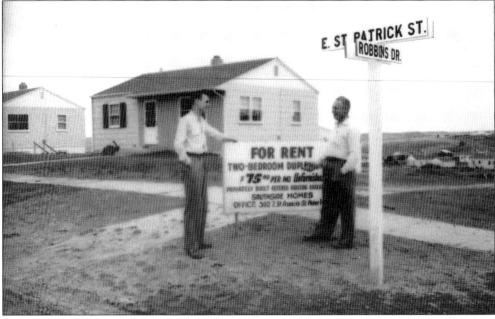

Robbinsdale was a new suburb beginning at the intersection of East St. Patrick Street and Robbins Drive. Lumber mogul Joe Robbins pioneered the home-building business in Rapid City and was financing young families 15 years before there was a Farmer's Home Administration agency. These privately-built duplexes by Southside Homes Corporation were designated "defense" housing in the early 1950s and rented for $75 per month.

This attractive model home is part of the Marcoe Homes addition in the area of West Chicago and 44th Streets, representing the finest in 1950s quality living. The sign states that financing was available through Walter Pailing and the Rapid City Trust Company. This upscale residence featured Ruberoid shingles, Moduflow heat control, and Thermopane windows.

After mothers petitioned the city for safe crossings, traffic signs were installed to warn motorists to slow down for the "Red Brick" school two miles out of town on West Main at Sturgis Road in Greenacres. Also known as Upper Rapid School, District 20, the three-room building housed eight crowded grades and was held in special affection by those who attended. It is now incorporated into the enlarged Vanway Trophy factory and showroom.

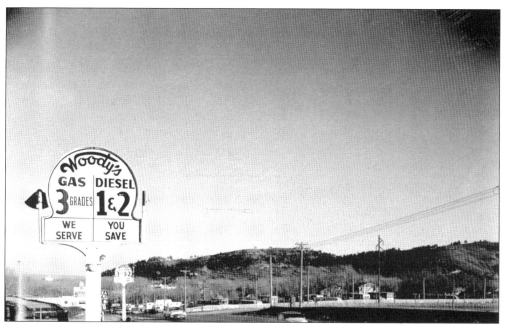

Looking east from the National Guard camp on West Main, Dinosaur Park and Hangman's Hill are in the distance. At the left is Elwood "Woody" Pelkey's gas station. Many buildings on the military grounds of Camp Rapid, right, were converted to residential rentals during the post-war housing shortage.

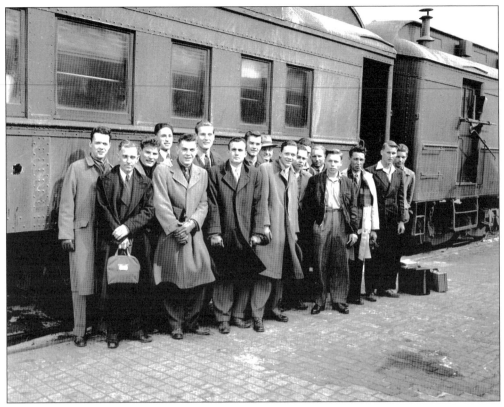

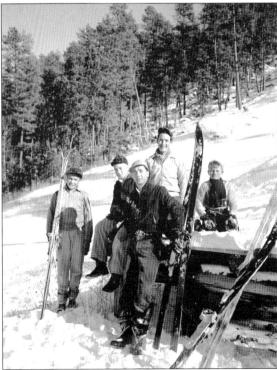

Gone to war. Young Rapid Citians at the railroad station are departing for Fort Leavenworth, Kansas and WW II duty in February 1943. Pictured from left to right are: Bill Evans, unidentified, Bernie Tennyson, Art La Croix, Bill Haley, Gene Sagen, Frank Carr, Dick Matthews, undentified, Jim Hackett, Billy Derrick, unidentified, unidentified, and Glenn Pope. The trio on the right is unidentified.

At Dalton Lake recreational area near Piedmont, Rapid City skiers get ready to hit the slopes around 1940. Pictured from left to right are: Bud Cullom, Harold Bulgreen, Jim Keck, Bruce Sisk, and John Groethe.

A replica of the 900-year-old Stavekirk in Borgund, Norway, the Chapel in the Hills near Canyon Lake was dedicated to the memory of Rev. and Mrs. Anton A. Dahl and "the glory of God" by their son, Arndt E. Dahl, on July 6, 1969. The Lutheran Vespers Hour, two million radio-listeners strong, was broadcast from here by Dr. Harry R. Gregerson. (Courtesy of *Rapid City Journal.*)

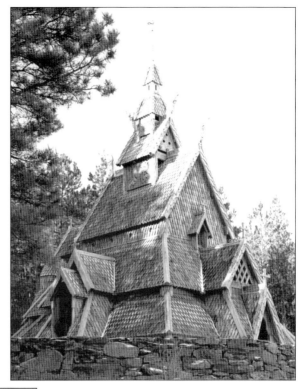

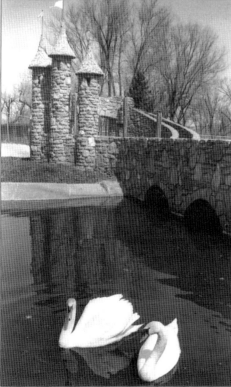

Castles and swans made the Rotary Club's Story Book Island a perfect fairyland. On August 16, 1959, an opening-day crowd of 10,000 persons filled its tiny two acres. Damaged in the flood of 1972, civic and private sponsors rebuilt nursery rhyme figures, enlarged the grounds, and added an open-air theatre. Christmastime means thousands of twinkling lights for magical winter memories. (Courtesy of *Rapid City Journal.*)

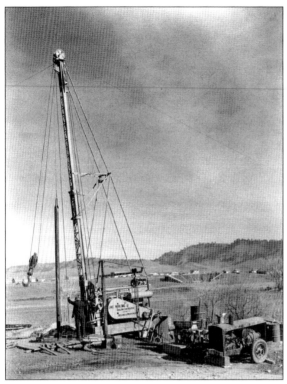

Workers dig a well on the Sioux Sanitarium, or Soo San, property west of town. Built in 1897, the government Indian School was converted to a $272,000 tuberculosis sanitarium in 1937. Once a part of the Rapid City Indian School agricultural farm, this tract was eventually acquired by Rapid City and other entities for development. Soo San remains the regional headquarters for American Indian health services today.

Harold W. Mills is pictured here sitting with the Mills Drug softball team. The Rapid City Softball Association League had ten teams and often played double-headers. Early in the 1940 season, Mill's Drug took second place to Warren Lamb Lumber with a batting average of .750 to Lamb's .800. The Twilight Softball League and the Rapid City Baseball Club also slugged it out on the North Park and Camp Rapid ball diamonds.

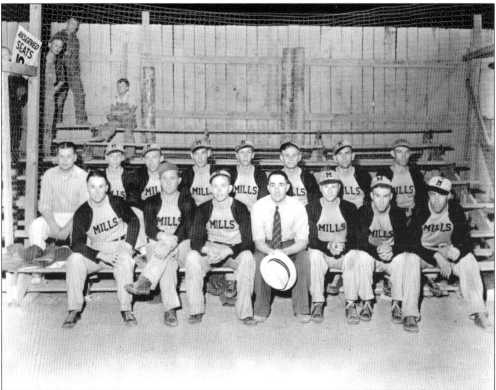

Six

THE BUSINESS SCENE

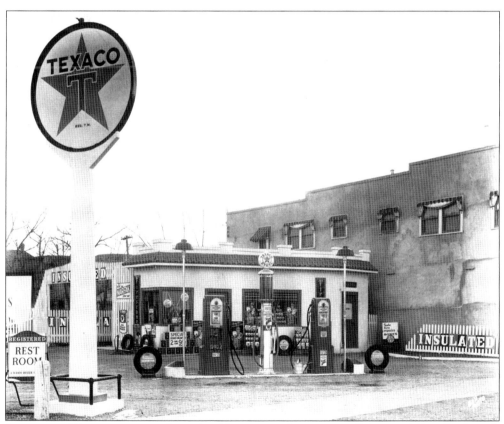

Interesting filling stations, such as this Texaco on the corner of Main and East Boulevard, provide an insight to motoring needs during the early days of Black Hills tourism. Bowman Tire Company is on the spot today.

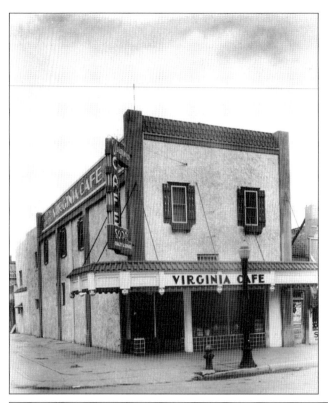

The Virginia Cafe at 632 Main was recommended by Duncan Hines in 1951. It was run in the 1940s by Erick Lund, followed by Fred Miles, and was located on the site of the American National Bank, now First Western Bank.

Dining out in Rapid City was not difficult. In 1937, Main Street alone had 19 eateries and 16 beer parlors within eight blocks. Noted for fine food since 1897, the A & F Café, with its potted palms and gilt-caged canaries, even had a branch in Deadwood. Gutzon Borglum ate there on his first visit to the Black Hills in the 1920s.

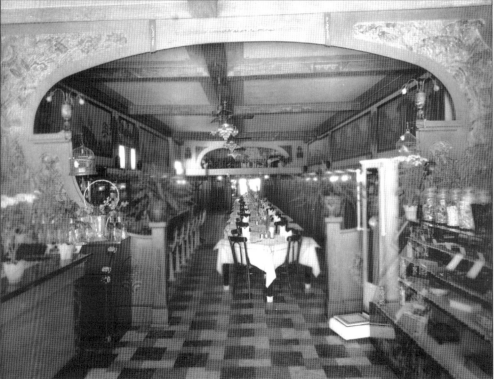

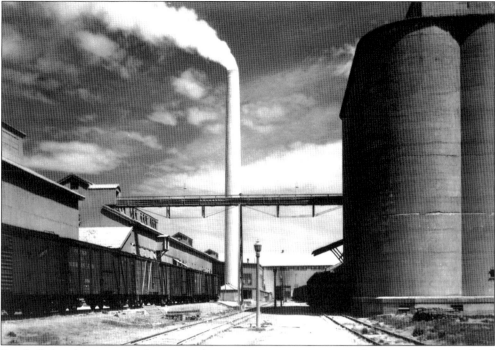

South Dakota's state-owned cement plant was a major revenue-producing source, using local materials since 1924. The brainchild of Governor Peter Norbeck, Paul Bellamy was its first manager. By 1929, there were 150 workers producing Dacotah brand portland cement. They could load 20 boxcars at the siding daily, with 800 to 1,000 sacks of cement per boxcar per shift. The plant was sold in 2000 to foreign investors.

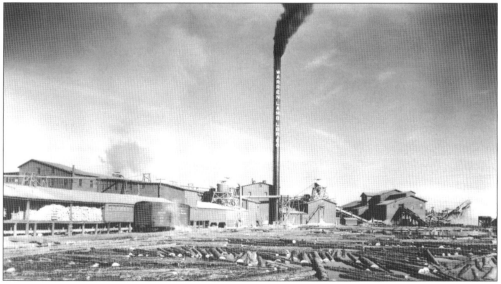

Warren Lamb Lumber Company was a giant Black Hills industry located at Rapid City's western boundary. In 1926, the U.S. Forest Service made the largest-ever regional timber sale of 62 million board feet to the firm—six years of work for 650–700 men producing 370 to 900 feet of lumber a day. A huge strike in 1930 and a devastating fire in 1931 kept the plant in the news.

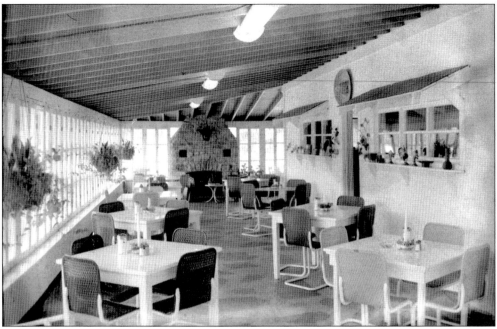

Called the Candle Light Drive-Inn, this popular eating place on S.D. Highway 79, owned by Fred and Gladys Brown, was much more than a mere drive-in. Featuring a fireplace and relaxed atmosphere in the 1950s, they were famous for their mountain trout, ribs, chicken-in-a-basket, and blueberry pancakes.

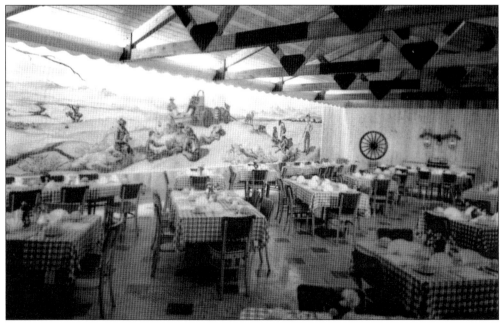

"Cowboy chic" is probably a good name for Rapid City's Western decor used in many local restaurants and nightclubs from the 1940s through the 1960s. The Chuck Wagon restaurant at 3609 Sturgis Road is pictured here on August 13, 1959—the atmosphere appears to be down-home and friendly.

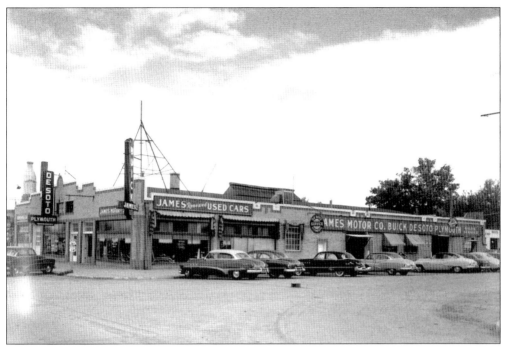

James Motor Sales has been a Rapid City fixture for years. In 1927, they sold Studebakers at 621 St. Joe. In 1930, they sold Buicks, then in 1940, the new DeSoto with its "floating ride" at 229 Main. De Soto's deluxe sedan cost $905 (fob) Detroit and had sealed-beam headlights, roller-bearing steering, and column shifting. James also promised unconditional guarantees on "renewed" cars.

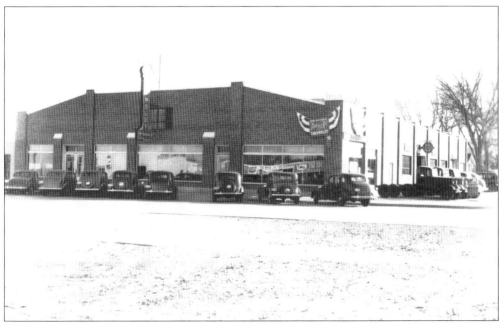

In 1938, McDonald's in Rapid City was an auto dealership. Located at Fourth and Main, this large Chevrolet garage occupied the building where TMA tires currently operates its downtown store.

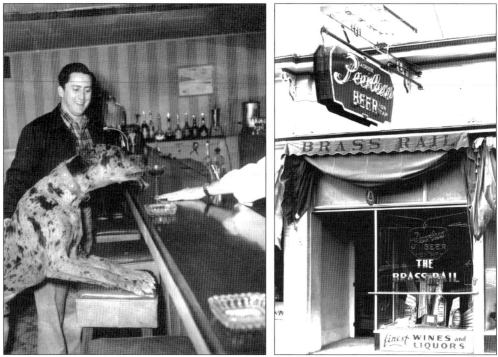

Esquire Club owner Don Hall, above left, appears to have really gone to the dogs with this martini-sipping pooch for a companion. The night spot, at 2700 W. Main, was a favorite of club patrons. The Brass Rail bar and cocktail lounge is still located at 624 St. Joe, just a half block west of the Alex Johnson Hotel. George W. Phillips was the proprietor in 1951.

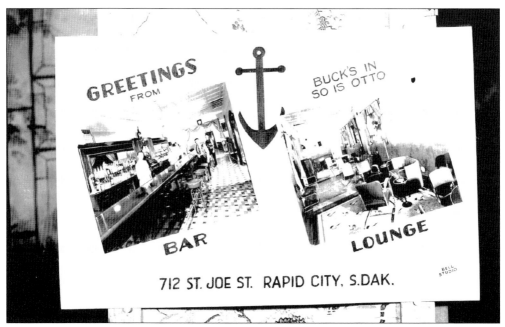

The Anchor Bar at 712 St. Joe was a popular downtown watering hole, as this postcard shows. Formerly called the Big Horn Bar, in early 1948 you asked for Bob, Monte, or Smitty.

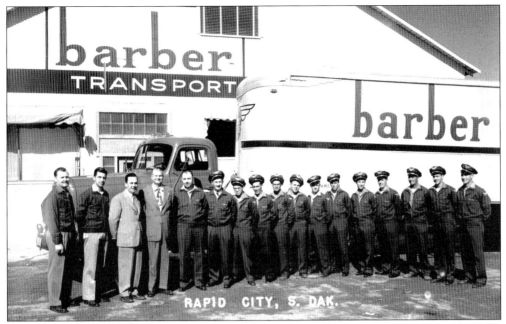

Barber Transportation employees line up for a company milestone photo on June 23, 1955. Milo Barber began the business in the summer of 1948 with 60 drivers and 35 units on the road. In 1955, he acquired leases to Booth Transportation Company, enabling his firm to handle freight directly out of Omaha, in addition to serving the 85 western Black Hills towns already served from their 321 Sixth Street office and warehouse.

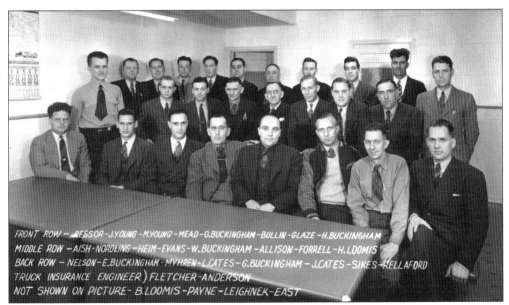

Another Rapid City motor carrier division sits for a group picture in February 1942. Representing Buckingham Transportation are as follows: (front row) (?) Ressor, J. Young, (?) Mead, O. Buckingham, (?) Bullin (?) Glaze, H. Buckingham. Middle row: (?) Aish, (?) Nordling, (?) Heim, (?) Evans, W. Buckingham, (?) Allison, (?) Forrell, and H. Loomis; (back row) (?) Nelson, E. Buckingham, (?) Myhren, L. Cates, G. Buckingham, J. Cates, (?) Sikes, and (?) Kellaford.

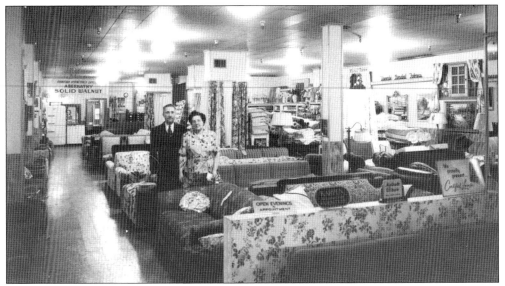

In 1929, Viola and Fred Dusek started a small used furniture store behind the Harney Hotel. They moved to the Duhamel building in 1935 and built their own store on West Main in 1940, priding themselves in selling top lines of home furnishings. The Duseks met when Viola came from Chicago to teach on the Rosebud Reservation and Fred was the local banker. Fred later became mayor of Rapid City.

Luxury flooring in post-war years was most likely to be linoleum rather than carpeting. T.J. Scholl's Flooring Store at 613 St. Joe offered many colorful patterns to choose from in June of 1948. For whatever reason, linoleum and tile departments were frequently located in dim store basements that had unsightly exposed pipes overhead.

Bill Groethe first apprenticed to photographer Bert Bell when he was only 11 years old, helping to shoot the first construction photos of Mount Rushmore. Before and after WW II, he worked for Bell Studio, and then ran his own commercial, photo finishing, and aerial photography operations. In August of 1960, Bill installed the first full-color photo processing laboratory in five states and is still going strong over 40 years later.

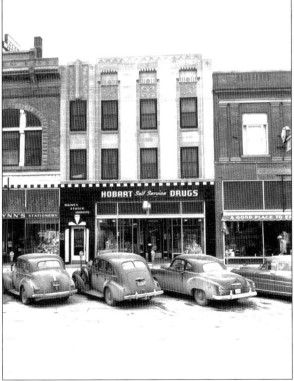

Downtown businesses have changed in many ways over the years. It is always interesting to see who occupied certain locations decades ago. On August 21, 1948, Dick and Lee Hobart opened Hobart Self-Service Drug at 613 Main. Rapid City's newest pharmacy featured an open counter prescription department.

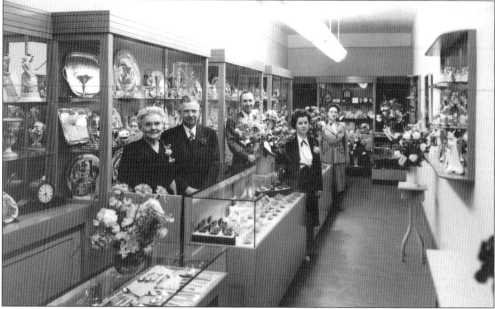

Wick's Jewelry Store shows Mr. and Mrs. Walter Wick and staff during the 1948 grand opening of their new store at 620 St. Joe. On April 28, 1942, the Wicks published the notice that due to war rationing, silver-plated flatware would soon be discontinued. They urged customers to use their lay-away plan and buy now. Clem Bourquin was a longtime employee.

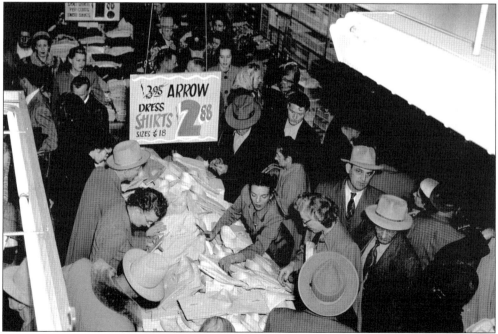

Perhaps as irresistible as grand openings are going out of business sales. Osborne's classy men's store at 518 Seventh was sold in October 1951, and all inventory needed to be liquidated. Men's dress shirts were marked as low as $2.88, and there appeared to be a mountainous supply of them.

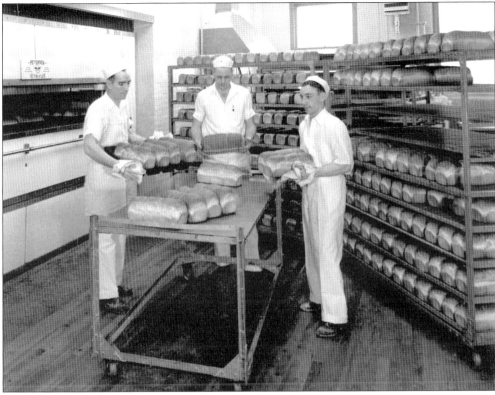

Harry Swander founded his bakery in 1891 and started a family legacy lasting through several generations. Some popular products were Sunbeam and Long Boy breads. The Long Boy loaf featured an Indian brave on its label and was advertised as "South Dakota's favorite bread." In 1942, its packaging was changed to a red and white striped design to accommodate Uncle Sam's wartime request for ink coverage reduction.

"Can't compare for shoe repair" was the slogan of Bode's Shoe Renewing in 1928. Located in the Bellamy building at 722 St. Joe, Bode's carried on substantial trade with local patrons.

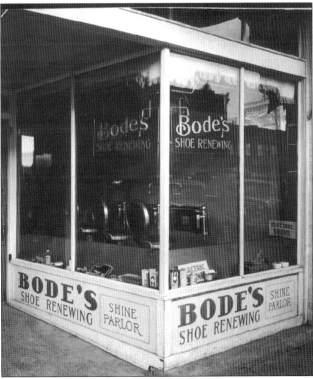

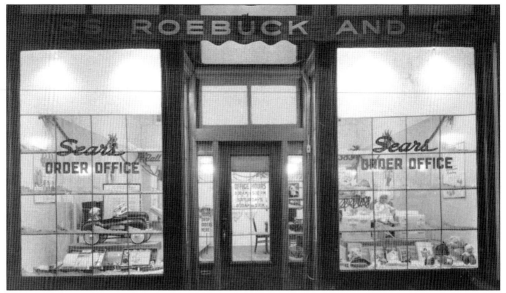

The Sears Roebuck catalog order store was wish book headquarters in this pre-Christmas photo of the early 1940s. There was even an after hours order drop off slot. Besides the pedal car in the window, Sears displayed a Lionel electric train, an Erector set and Fort Dix play set, children's books, and scarce Noma Christmas lights. In 1946, Sears opened their modern department store at 514 Main.

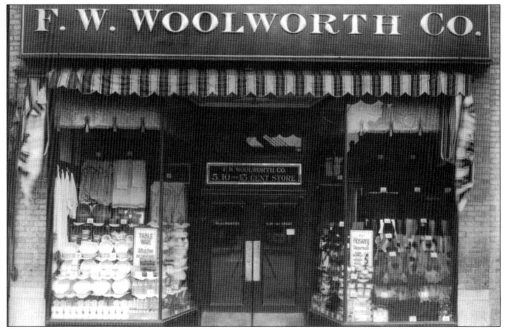

The ever-popular five and dime was represented in Rapid City by Woolworth's until the mid-1990s. Shown here in the 1930s are window displays of hosiery and inexpensive housewares at 627 Main, where Terry Rathbun served as manager. Upstairs were offices for Williams and Sweet and George Hurst, lawyers, and Ralph Wick, optometrist. Woolworth's later store with its long lunch counter was a popular noontime eating place for downtown workers.

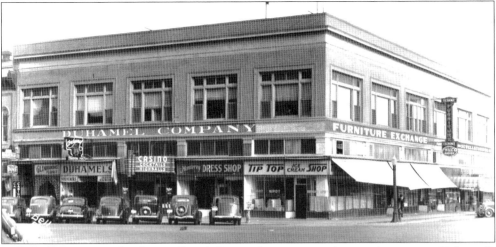

Duhamel's is a name familiar to Rapid Citians from pioneer days to the present. Duhamel's department store across from the Alex Johnson Hotel also sold ranching supplies and had a fine saddlery and harness department. The household and dry goods phase of the family-owned enterprise closed in 1929, succeeded by their popular Western trading post concept, ably managed for years by Bill Blanton.

There was a near riot at the ribbon cutting ceremony for Rapid City's newest Red Owl store on July 30, 1942. Ground meatloaf containing beef, pork, and veal was only 39¢ for two pounds and Armour's AA grade roast beef cost 25¢ per pound. However, rationing decreed that no stockpiling was allowed. Rapid City, for its small size, supported three chain and numerous local grocery stores.

Alice Gossage, wife of *Rapid City Journal* founder Joseph Gossage, was one of the city's most beloved philanthropists and columnists. Always ready to help those in need, she kept an ever-full donation box of clothing and necessities at the newspaper office for the use of anyone who needed them, and could always be counted on to head local charities and community fundraisers. (Courtesy of *Rapid City Journal*.)

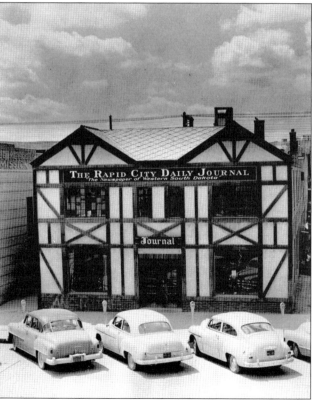

One of the Black Hills' earliest newspapers, the *Rapid City Journal* was established in 1878. Shown at its former location of 507 Main, competition between rival papers was keen. The daily *Journal* prided itself on integrity and was one of a handful which prevailed. In the 1950s, Elliott "Paddy" Ingvalson was managing editor, Warren Morrell was editor, and Bob Lee headed the new Sunday edition. (Courtesy of *Rapid City Journal*.)

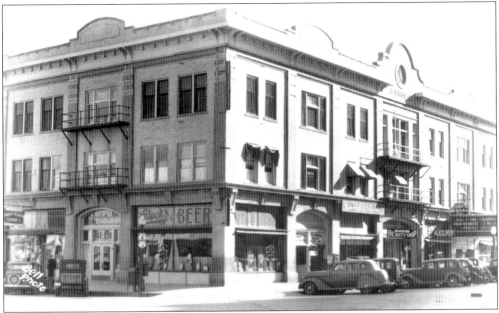

The Elks' building at Sixth and Main dates to 1912. It originally held an opera house, meeting rooms and commercial rentals. Elks' Theatre, located on the main floor, showed "Men of Daring," the first major film made in the Black Hills, in 1927. Past tenants were the Silver Star bar, operated by Les Ripple with its Western Union sports ticker, Coast-to-Coast, Modern Beauty Shop, and Lamphere Insurance Company.

Rapid City founder John Brennan ran the Harney Hotel, built in 1887, for many years. A three-story brick structure with a mezzanine overlooking the lobby, the Harney had 70 rooms renting for one dollar per night. This second floor modernization took place in the 1930s. Tailor George Moses had a shop near the front desk and frequently claimed he could hear any conversations taking place there.

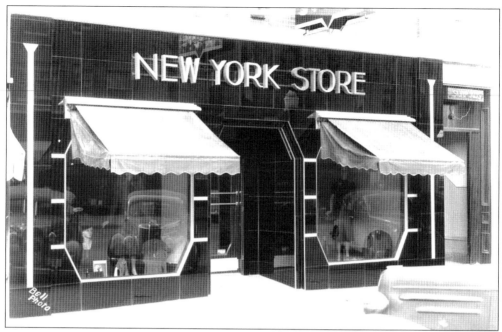

The New York Store was on the cutting edge of fashion in downtown Rapid City. The ultra-modern facade gave a sophisticated look to its location at 610 St. Joe. The latest in ladies' clothing was personally selected by owners Abe and Myrtle Blumenthal.

Ruth's beauty salon passed inspection in August 1940, according to her license on the wall. Utilizing a delightful bit of Art Deco styling, Mrs. Ruth Kambak was open for business at 628 St. Joe. Some of the products on the shelves are Madeline's white satin skin lotion, wave oil, and Klirzol skin creme.

Going up at Eighth and Kansas City is the new Northwestern Bell telephone company building in this June 12, 1953 photo. Telephone usage moved ahead under the direction of district manager John Duff, who retired in 1948 after 21 years of area service. Under Duff's leadership, telephone subscribers increased from 2,600 in 1938 to 8,000 in 1948.

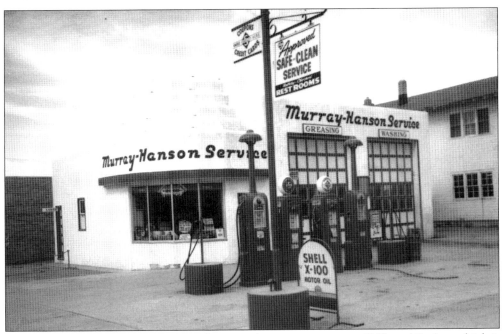

"Ping" Murray and "Ax" Hanson ran their popular service station at Fifth and St. Joe, which is now the Mr. Nifty Dry Cleaners establishment. The photo was taken May 15, 1951. Murray and Hanson also sold Dodge cars and had a used car lot at 420 and 418 St. Joe, with partners N.G. Gikling and Floyd Hesler.

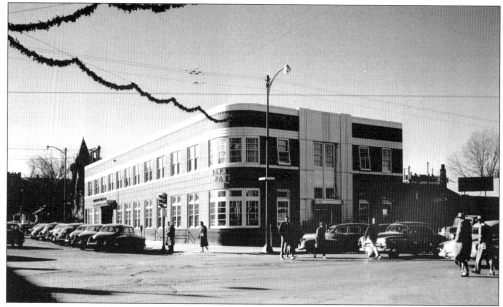

Rapid City National Bank opened at Seventh and St. Joe on April 11, 1934 with Roy Dean as president. A new building was dedicated on June 11, 1942 with much fanfare and a grand opening that drew 9,000 people. Many Black Hills materials were used in its construction, and in addition to two floors of finance, 19 tenant spaces were rented out.

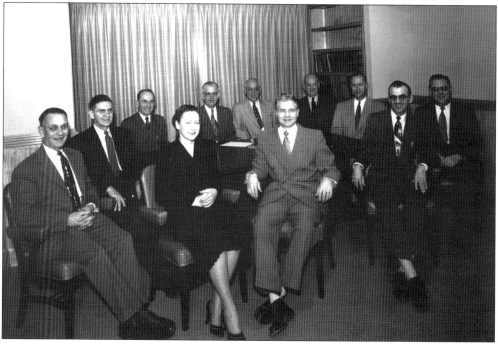

Executives and staff of Rapid City National Bank in 1951 are pictured as follows: A.E. "Art" Dahl, president; H.J Devereaux, vice-president; W.E. Shoberg, vice-president; Earl Keller, vice-president; Roy Dean, board chairman. Also pictured are Walter Pailing, Fred Barth, Gilbert Ellewein, Frances Vincent, and Russell Halvorson, cashiers.

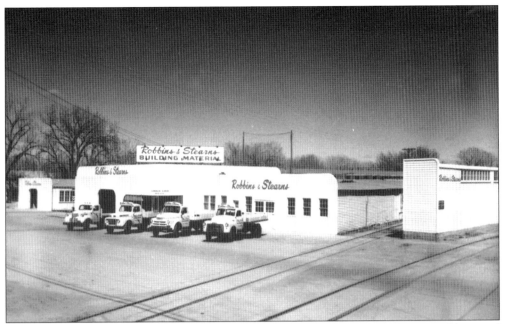

The Robbins and Stearns lumber yard at 312 Eighth was started in 1907 by Joe Robbins and Cliff Stearns, who first delivered lumber in a horse-drawn wagon when the town's population was 3,000. After WW II, there was an acute housing shortage in Rapid City, and Robbins and Stearns Lumber Company became actively engaged in providing the materials for new neighborhood communities.

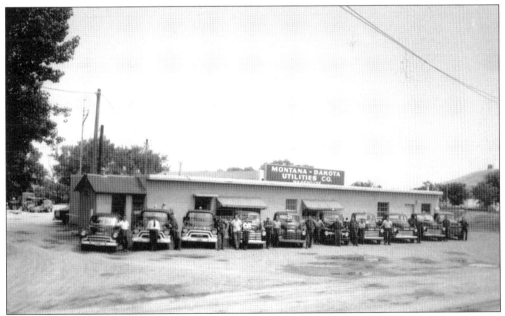

This crew of Montana Dakota Utilities workers is probably much more efficient than those who first turned on the natural gas in Rapid City on October 18, 1928. Rapid City was the last city to hook up to the 184-mile long Baker-Glendive pipeline, at a cost of 2 million dollars. By March of 1929, there were 936 customers, and in 1951 there were over 6,000.

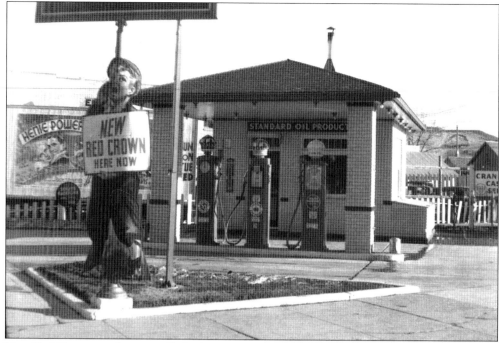

New Red Crown gasoline was all the buzz in 1940. "It's 2 to 1 among Midwest motorists," said the ads. Red Crown regular boasted 70 octane over Standard Oil's basic Stanolind brand at 55 octane. This filling station on highways 14, 16, and 79 is probably the Standard Service Station, later "Andy and Pete's" at Sixth and St. Joe. Reservoir Hill is in the background.

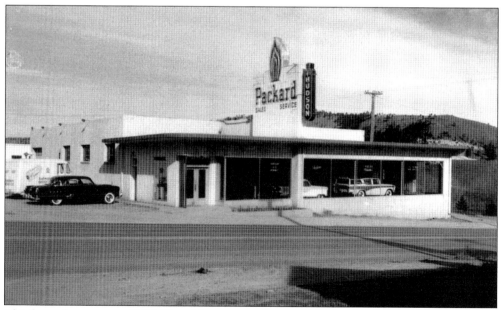

This huge showroom at 2520 West Main was nicknamed "Packard Hill." Packard Rapid City Company owner Paul Thomas moved his business from downtown to the country. West Main was part of the suburbs of Providence and Greenacres until October 11, 1947, when the city annexed them and the adjoining areas of Canyon Lake Park, Baken Park, and Harter additions.

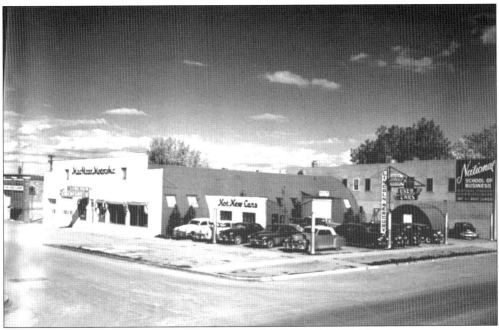

"Dicker with MacVicar" was Arch MacVicar's slogan in the Lincoln-Mercury showroom at Fourth and St. Joe in 1951. The dealership later became Gene Sagen's Courtesy Lincoln-Mercury at the Cross-town Motors location. On September 29, 1948, MacVicar was completely sold out of used cars. "Sorry!" their ads read, "some next week."

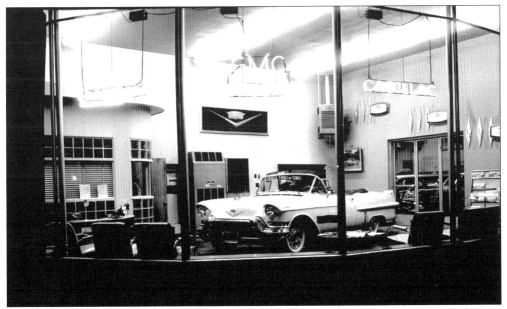

Rapid City's population seemed extraordinarily thrilled with new automobiles for its relatively small size. But then, who wouldn't love cruising in this shiny new convertible from Black Hills Oldsmobile and Cadillac? In 1929, the salesroom was west of the Harney Hotel and there were branches in Deadwood and Spearfish. Tom Collins managed at Fifth and Main in 1938. This modern brick building is still at 601 Kansas City.

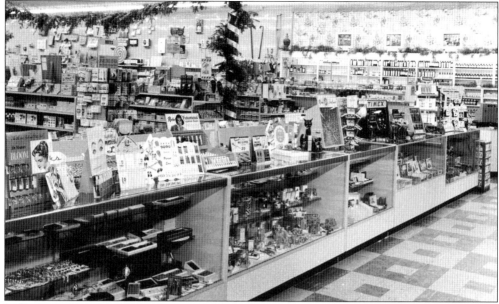

Mills Drug stores had several outlets around town at convenient locations. The cosmetics and jewelry section of the new Baken Park store is shown just before Christmas in the early 1950s, though its contemporary look could pass for today's retail displays. During construction of the air base in 1942, Mills stayed open 17 hours a day and provided a lunch-packing service for workers.

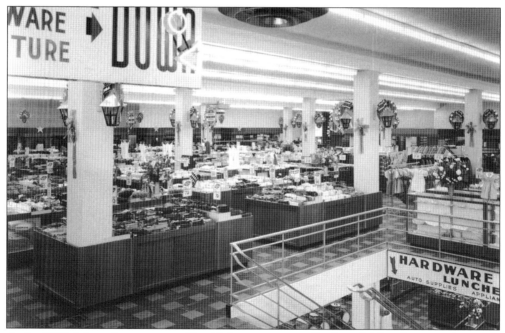

At its 1947 debut, the prototype Gamble's superstore at Sixth and Main became America's largest Gamble's department store. Robert E. Driscoll, president of First National Bank of the Black Hills, was instrumental in bringing the million dollar store here. With a $250,000 annual payroll, Gamble's served a five-state radius. Managers were Ralph Swenson, Clayton Howe, Gene Thompson, George Trowbridge, and Lloyd Burroughs.

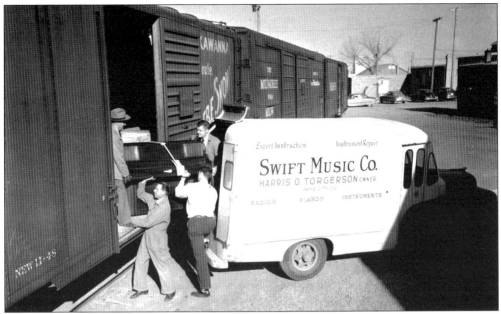

It probably took some fine tuning for the crew to get this piano to its destination, which was Harris Torgerson's Swift Music Company at 617 St. Joe. The photo was taken on May 7, 1951.

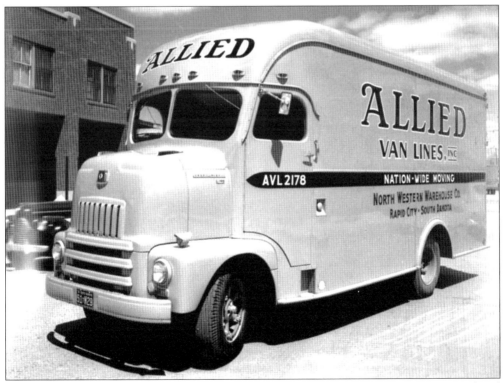

Allied Van Lines could move the above piano and the entire household with their streamlined fleet of new trucks. Operating from the Northwestern Warehouse building, they were top-of-the-line for quality service in 1951.

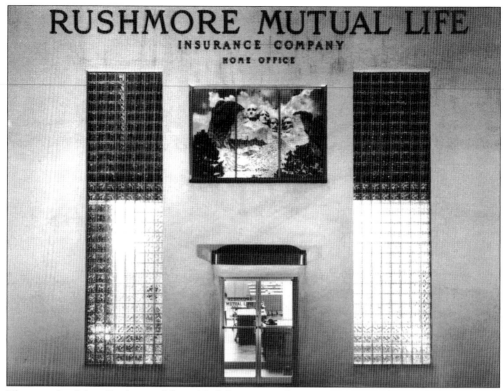

The new facelift at Rushmore Mutual Life Insurance Company, 613 Ninth, was dedicated with fanfare at an open house on May 14, 1949. Started by Carl M. Anderson in 1939, the firm employed 102 people in five states. Vice-president C.K. Dean and pilot Jerry Snedigar once flew 3,000 miles in 30 days to promote company business. Bell Studio and Bill Groethe created the illuminated Mount Rushmore mural. Rosenbaum Signs lighted it.

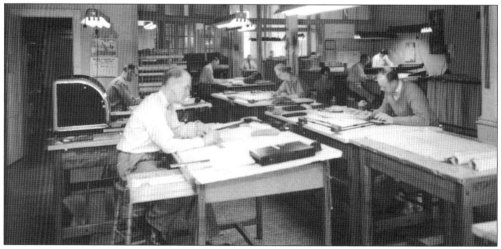

President Julian Staven is at his desk at the rear of Staven Engineering Company. Besides drafting and mechanical services, Staven operated an aerial photography business with Bill Groethe, which ultimately would prove to be a record of Rapid City's growth on film. This photo dates to March 27, 1954. Office Manager Vic Rugg is pictured at left. Jerry Thomas is on the right.

The Haley brothers and an enticing coffee display at the Bean Bag Food Market, 102 East Boulevard. The store was formerly at Fifth and Main. On July 2, 1951, the Haleys announced a raffle for a pair of "three-year-old palomino horses to be given away absolutely free—no purchase required."

Safeway's new west side store across from Baken Park is attracting the usual number of sidewalk superintendents and future superintendents to oversee its construction. The date was January 5, 1952.

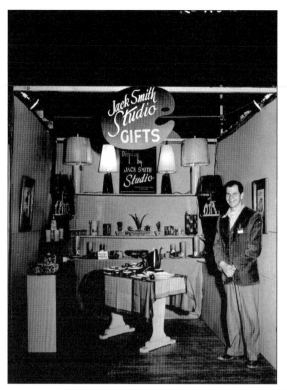

Jack Smith, proprietor of The Studio, was avant-garde in his home decorating atelier at 1118 West Main across from Halley Park. Smith sold crystal, brass, Red Wing dinnerware, and locally-made Rushmore pottery to a select clientele, and sponsored one segment of a local radio broadcast hosted by Verne Sheppard in the early 1950s.

Vitali Tile Company, owned by Louie Vitali, also sported an ultra-modern look in 1953. Located at 3535 Sturgis Road, Vitali was also associated with Scholl's Flooring downtown. John Scholl was vice-president of the Vitali Company.

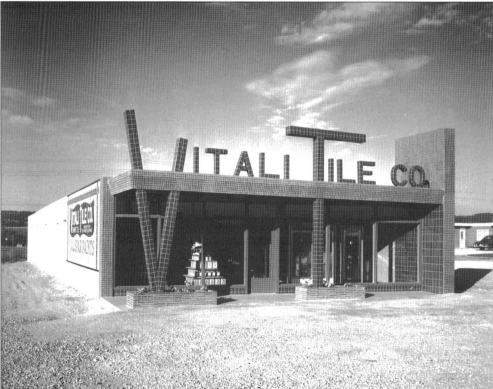

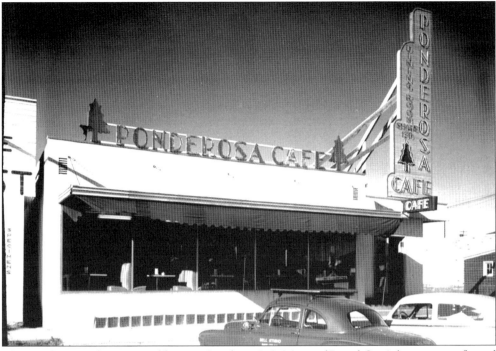

The Ponderosa cafe is pictured here in October 1949. Many of Rapid City's businesses reflected the western, or "outdoorsy," look that was pleasing to locals and visitors alike.

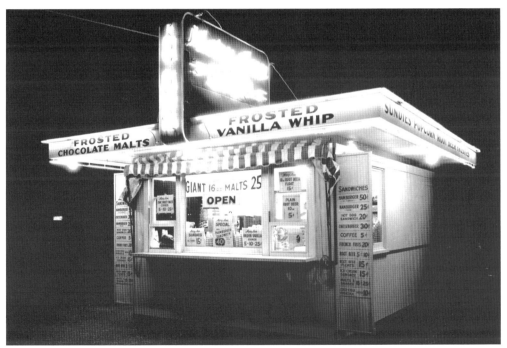

While the Mary Ann Drive-Inns didn't stay long in Rapid City, in 1951 there were two drive-ins and two retail locations. None remained by 1955. This one on Eighth Street was next to Jensen's Motel on the way to Mount Rushmore. It featured malts for just a quarter.

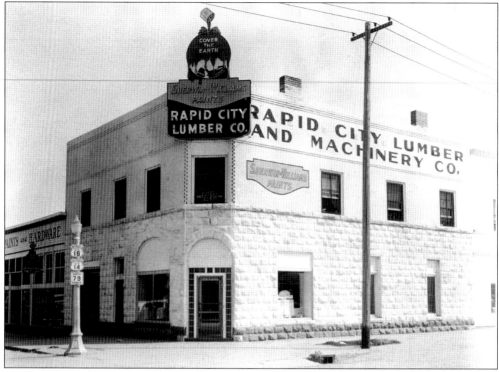

Rapid City Lumber and Machinery Company at 413 St. Joe also served as a dealer for the Reo Flying Cloud automobile in 1929. In the 1920s and 1930s, they sold Valdura asphalt paint to farmers, which offered a special coating ability to protect farm implements from rusting.

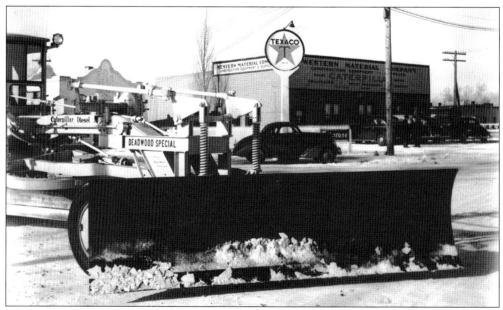

This Caterpillar road grader and plow in front of Western Material Company is called The Deadwood Special. This picture, taken on December 15, 1948, shows the buildings to be on the east end of town. The dealership had branches in Sioux Falls and Aberdeen.

Seven

ENTERTAINMENT
TONIGHT

Mrs. Lois Martin's Gate City Dancing Revue fills the stage at old Rapid City High School in this 1948 photo. Pupils from Lois Martin's School of Dance were frequent performers at luncheon-style shows held Saturdays at the Alex Johnson Hotel. Carroll Teaney was the dance director in 1955.

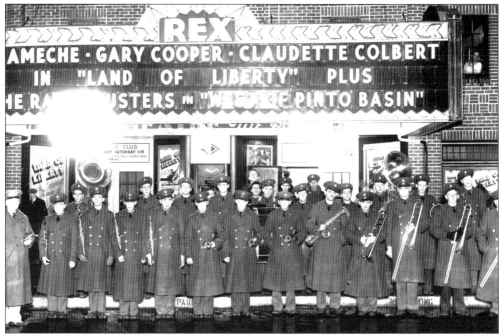

The Rex Theatre featured the RCA Photophone system for cutting edge projection fidelity. In early 1930, the Rex showed *The Lost Zeppelin*, starring Ricardo Cortez and Virginia Valli. They advertised that this was the talking picture shown in New York for $2: "You see it for 30 cents." Owned by Black Hills Amusement Company, the Rex underwent major a renovation in 1960.

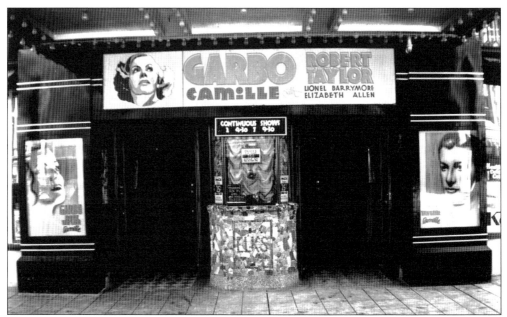

Said to contain a resident ghost, the Elks Theatre at 512 Sixth took on new life several years ago and is currently Rapid City's only downtown movie house. In June 1927, the Elks showed exclusive daily footage of President Coolidge's stay here and premiered *Men of Daring*, the first full-length movie filmed entirely in the Black Hills. Tickets cost 10¢ to 40¢.

Drive-in theatres were another post-war phenomenon. Construction of the Starlite Drive-In began in August 1948, east of town and at the west end of Superior Airport on highways 14 and 16. The complex held 650 cars on special rolling ramps facing a gigantic 56-foot square screen. Most popular movies of the day were the Westerns and double features at one dollar per carload.

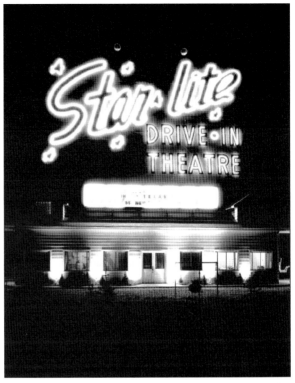

Originated by educator E.B. Bergquist in 1930, the West River Music Festival provided annual symposiums for regional high school musicians and choruses. Massed concerts were presented, for public enjoyment. The Lead High School band is strutting their stuff in the big parade of regional bands in May 1940, when 1,700 students were in attendance.

Members of the Rapid City Choral Club were led by Rev. R.C. Reinholtzen in the 1930s. Rapid City had a grade school glee club directed by Miss Gertrude Bachmann, a men's Nordic chorus, the Paha Sapa Chorus, and several church choirs. The Shrine of Democracy chorus and Sweet Adelines barbershop groups continue to perform to enthusiastic audiences.

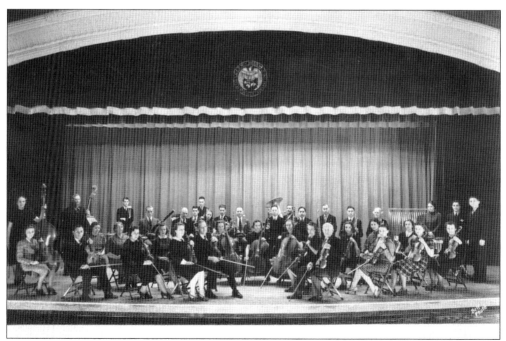

Poised on the stage of the Rapid City High School auditorium, the Rapid City Civic Orchestra prepares to give another fine performance under Alex F. Schneider. Rapid City has been a generous supporter of arts and culture-based programs.

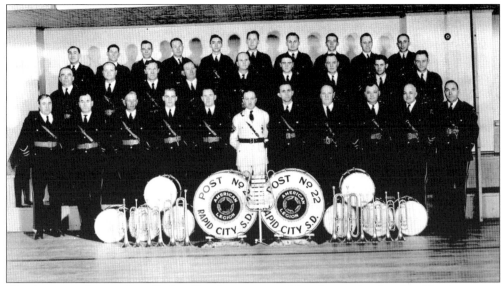

The American Legion Post 22 Band has been a part of the chapter for decades. The director in the photo unfortunately couldn't be identified, but for many years Art Niedan was associated with heading up American Legion band activities throughout the state. When Niedan moved to Rapid City, he directed this band, the Seventh Cavalry Drum and Bugle Corps, taught music, and repaired instruments.

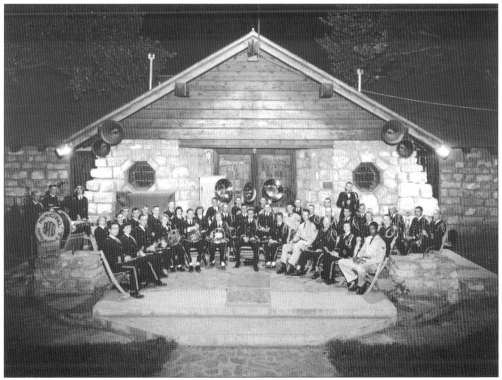

A night concert at Halley Park is provided by Rapid City's municipal band under the direction of Arnold Rudd in the early 1950s. Beginning in 1926, Rapid City also had its own military band.

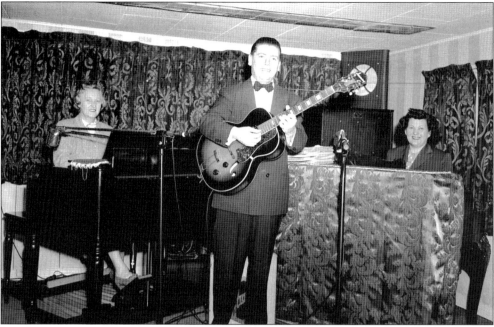

Popular entertainer Alice "Allie" Hand, "the sweetheart of the Dakotas," appeared regularly with her Hammond organ at the Esquire Club with pianist Eddy Brzica and guitarist, singer, and master of ceremonies Danny Morris. Every Tuesday, Thursday, and Saturday the trio was broadcast live over KOTA radio at 9:15 p.m. The nostalgic photo was taken on February 12, 1948.

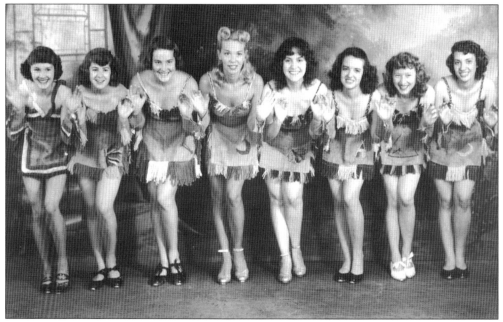

Don and Betty Jean Crosby ran a dance and personality school at 601 St. Joe with additional locations in Sturgis and Deadwood in 1951. These lovely ladies appear to be apt pupils. The Crosby studio was at 2802 West Main in 1955, where they offered individualized ballroom dancing instruction for couples at 10 lessons for $18.75.

Billed as the Daughters of the Pioneers, Bette Orrick and her group of singing and yodeling cowgirls had their own local radio show. It seems hard to realize that it was so long ago.

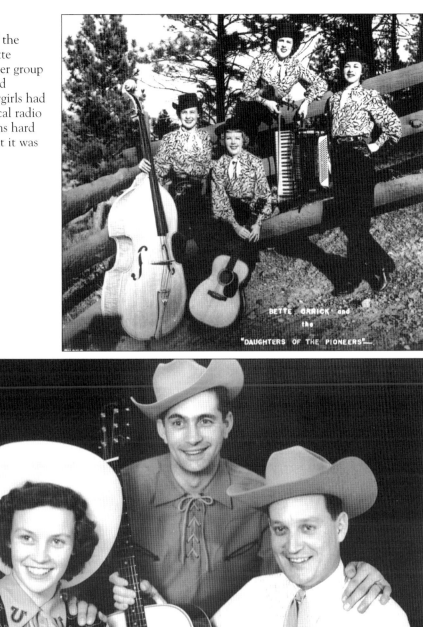

Buddy Meredith, right, is still going strong. Pictured here with Polly Johnson, the pair made up the Buddy and Polly show team over at KOTA radio in the 1950s. Gene Taylor, center, was the announcer. Taylor later began KIMM radio station. Meredith was part of The Dakota Cowboys in the 1960s and the Circle B Cowboys through the 1990s, when the group became simply The Cowboys.

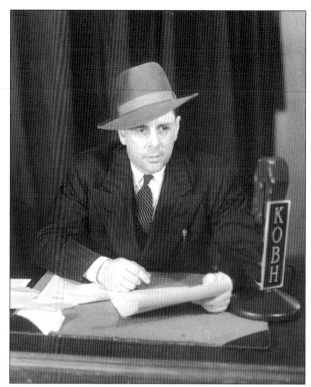

Presenting all the news that is news, George Bruntlett was heard over KOBH. *Call of the Black Hills* was broadcast at 1400 kilocycles on "the friendly spot on your dial," which began in 1939. Harry Petersen was the station's longtime program manager. Carl Quarnberg was the owner.

President of KOBH and Black Hills Broadcast Company, Bob Dean sits in his penthouse office on the 10th floor of the Alex Johnson Hotel. In October 1944, KOBH obtained permission from the War Production Board to expand from 250 to 5,000 watts of power to provide aid for wartime communication through Rapid City Air Base. A CBS affiliate, KOBH was acquired by Duhamel Enterprises and became KOTA.

Eight

RANCHING AND AGRICULTURE

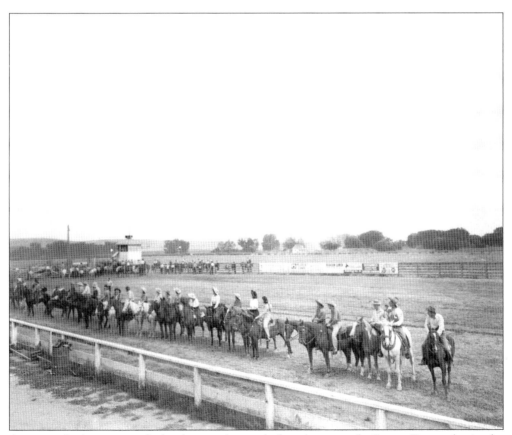

A group of riders gets ready for the grand entry before the start of a Range Days rodeo in the early 1950s.

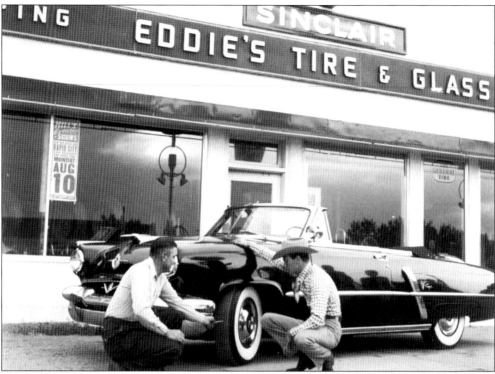

World champion rodeo great Casey Tibbs listens intently as Eddie Rypkema gives him tips on caring for his new white sidewall tires. Tibbs, a native of Fort Pierre, South Dakota, held multiple world titles in all-around and bronc riding divisions in the 1950s and 1960s.

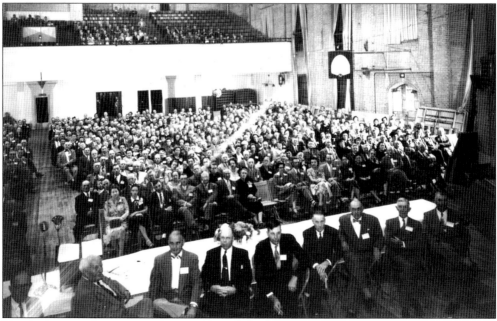

Hundreds came from across the nation to attend the 35th Anniversary of the Land Bank Conference held September 25–26, 1952 at Rapid City's municipal auditorium.

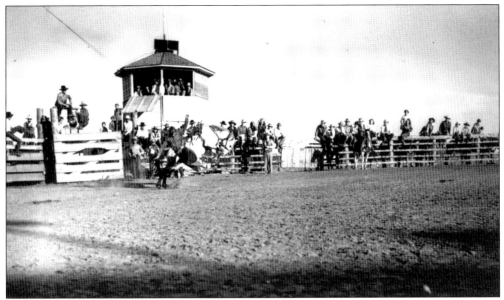

Bucking stock provided by Russ and Gene Madison guaranteed thrills and spills for Black Hills rodeo fans over decades. Here, the outlaw horse Comanche unloads his rider at a Range Days celebration a couple generations ago.

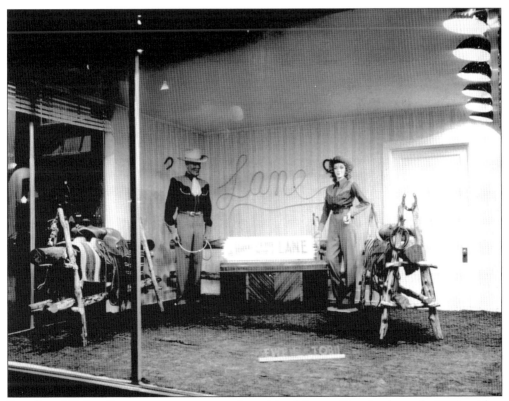

Sewell and Tobin Furniture store got into the spirit of Range Days in the early 1950s with a romantic cowboy and cowgirl theme for their line of cedar chests. "He corralled her with a Lane."

A part of the old Holcomb HO ranch east of Rapid City lies deserted in this photo. The Holcomb place was a hub of activity during the days of the cattle baron. The huge ranch house served as a gathering place and as a boarding house for railroad crews in the early 1900s.

As more families left their farms and ranches for city life, country schools like this one, thought to be in eastern Pennington County, were boarded up. Just down the road, the sign in the field lists land for sale at $50 to $75 an acre in the fall of 1956.

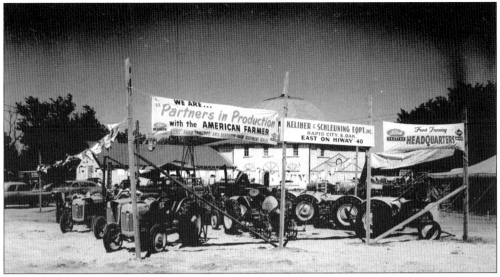

Called the Western Dakota Fair, the Western South Dakota Fair, the Alfalfa Palace Fair, and, currently, the Central States Fair, this annual fall exposition and rodeo has been at its present location since 1919. The Alfalfa Palace building, shown here in the background in August of 1951, has held exhibits, boxing matches, baby contests, and Saturday night dances. Who can remember The Gumbo Lilly Kids and the Rapid River Ramblers?

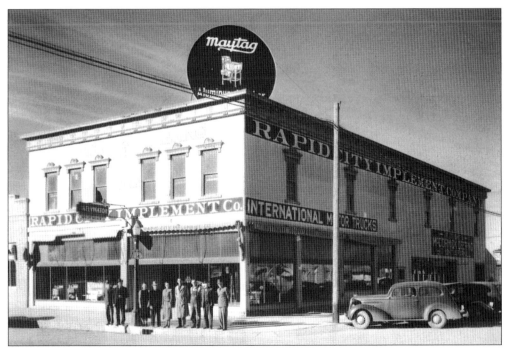

Rapid City Implement at 802–812 Main was the farmers' friend. "Up-to-date-and-Johnny-on-the-spot" John Boland sold everything from washing machines to hay balers. During WW II, Boland actively collected scrap metal and somehow found the time to be Gutzon Borglum's financial manager and right-hand man on the carving of Mount Rushmore. He is pictured in the homburg hat.

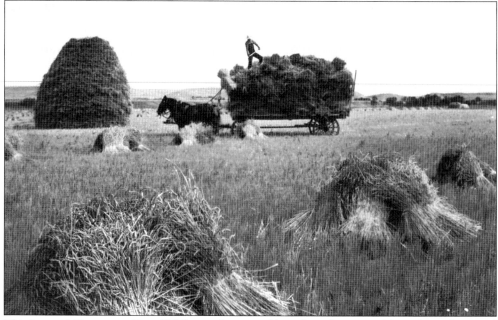

This bountiful harvest in Rapid Valley perhaps would not have been possible without the Rapid Valley Irrigation Project—a part of the W.P.A. program in 1940, and the Great Plains Land Use program. Pennington County Extension Agent Ray Lund oversaw the $2.5 million effort which created Pactola reservoir, above Rapid City, to provide a municipal water source and needed irrigation to ranchers.

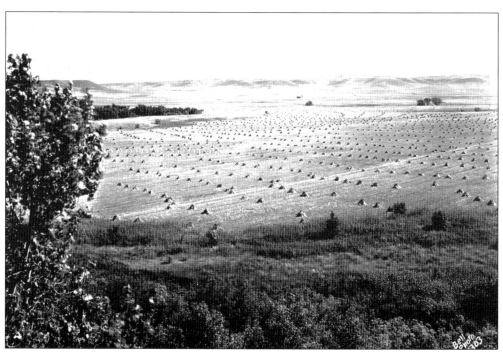

Prosperous crops are vital to the overall economy of a region. Rapid City has thrived on its status as a supplier of goods and services to a large area.

Farm and Ranch Day at Knecht Lumber Company brought out crowds of rural folks to see the latest in building and farm products on May 16, 1957. Remote broadcasts from KOTA radio urged neighbors to come on down and get a hot dog and cold drink and stay around for a little square dancing later on.

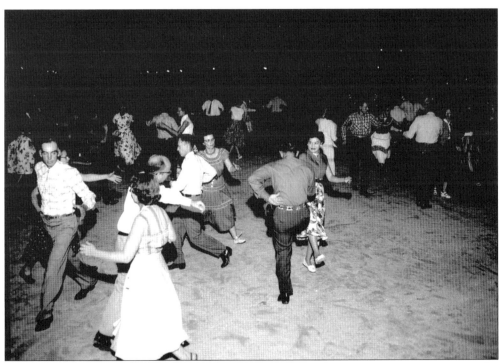

And here is the square dancing later on. It didn't take much encouragement to get into the musical swing of things in the good old days.

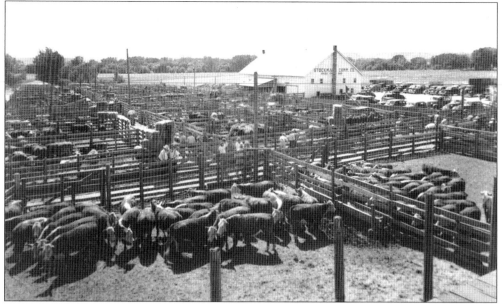

The Stockman's Commission sales yard, a half mile east of the fairgrounds, was a busy place that provided valuable services to stockmen, both for buying and selling. Revenues, back when a dollar was worth much more than it is today, often reached nearly a half million dollars annually. A few old cowboys can recall when bidding contests sometimes lasted until the wee hours of the morning.

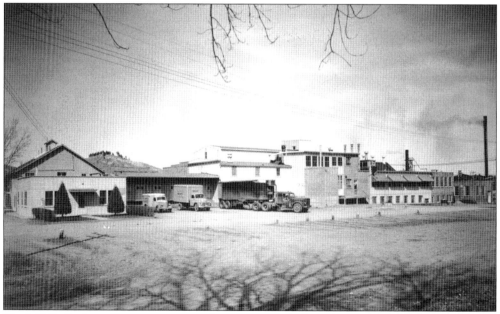

Black Hills Packing Company was another important link to the regional economy. Founded in the western gap at Oshkosh and Chicago Streets in 1909, prominent local businessmen were the stockholders. A downtown retail operation and a delivery route boosted sales of Rushmore brand products until 1939, when the company began to distribute through other stores. A major employer, the plant burned to the ground in January 2002.

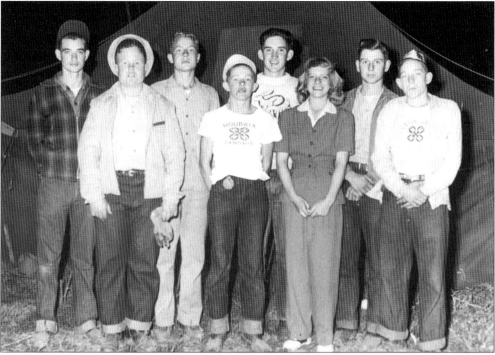

Raising kids who wanted to be involved with the family farm was an important part of rural lifestyles. These 4-H youngsters represent hometown clubs like the Roubaix Rangers in this 1947 photo.

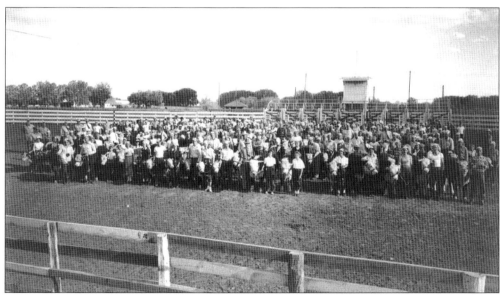

The Western Calf Show originated in 1937 under the guidance of Enos Blair and Leo Meier. Competition was keen, with over 500 entries at this October 1947 show co-sponsored by the Western Calf Show Association, Black Hills Hereford Sales Association, Stockman's Commission sale barn, S.D.S.U. Extension Service, and the Rapid City Chamber of Commerce. The top animal, owned by Ross Jordan of Tilford, brought 85¢ per pound.

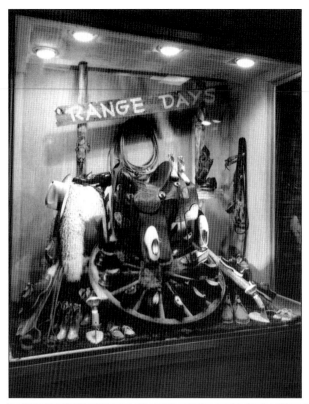

Vintage trappings adorn the Range Days window display for Sorbel Shoes, 621 Main, on August 17, 1953. Angora chaps, called "woolies," protected cowboys from the elements and thorny underbrush. The "loop-seat" parade saddle from a century ago, with its tooled eagle design and engraved silver corners, was definitely not meant for everyday use.

Sears Roebuck Company sported a saddle shop in their new store at 514 Main in 1946. The silver-trimmed saddles to the left are for parade and show—the plainer one is priced at $595. Saddles for ranch work cost around $300, about the same as a cowboy's monthly wages.

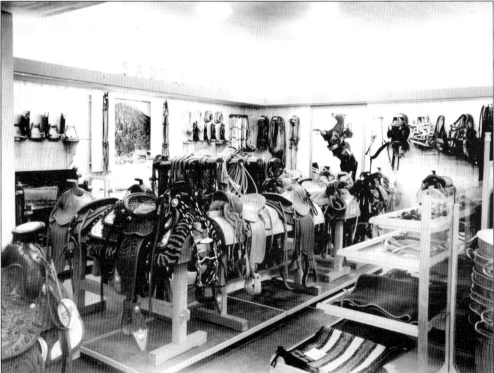

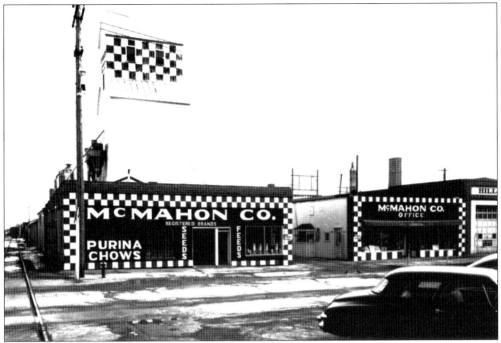

Certainly an easy place to find, McMahon Feed Company at Fifth and Main was started by Frank McMahon in 1896. The firm also operated a grain elevator in Sturgis. McMahon feeds were so widely used, they claimed that "80 percent of the alfalfa fields in the region were planted with McMahon seeds or its yields."

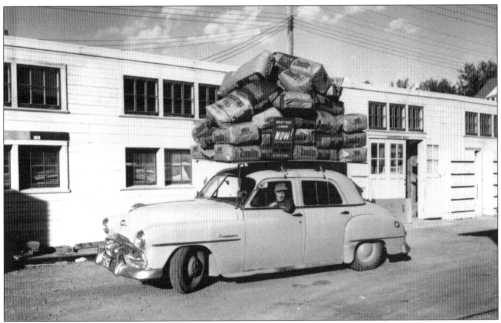

For those who didn't have a pickup truck, the family auto did extra duty. Knecht Lumber offered a car carrier service to move those sacks of insulation in September 1955. Hopefully, they didn't have far to go.

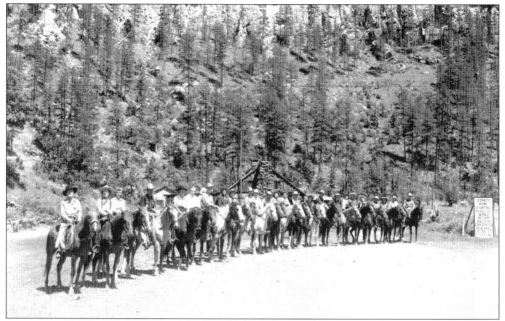

The Boots and Saddle Club was one of the organized groups that belonged to Black Hills Riding Clubs, Incorporated. Albert Gaarde was the president in 1956. Over 70 members from Rapid City, Sturgis, Whitewood, Deadwood-Lead, Central City, St. Onge, Belle Fourche, and Ellsworth Air Force Base got together for horseback treks through the Black Hills. This group is pictured at the Stratobowl around 1940.

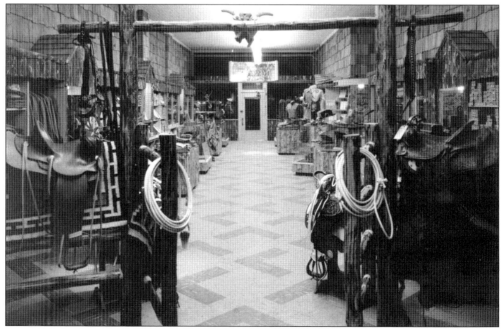

Lariat Clothiers at 705 Main had everything for the horse enthusiast. The smell of new leather was about all it took to pull out one's pocketbook. Boots, shirts, hats, buckles, and saddles were all smartly displayed in this April 9, 1949 photo.

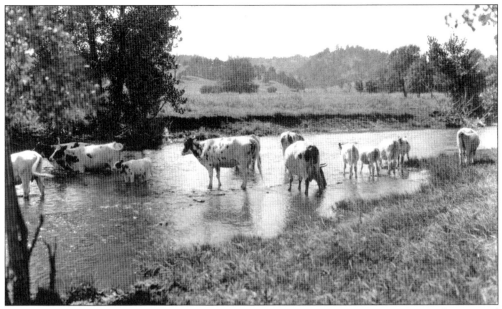

Raising dairy cattle was not as common as raising beef cattle in West River country, but several dairies flourished in and around Rapid City. These registered Ayrshires were part of the Dr. R.J. Jackson herd on Rapid Creek. Gus Haines, who herded these cattle as a young man, started his own dairy in the area. Milk consumption was high in Rapid City, newspaper reports claimed.

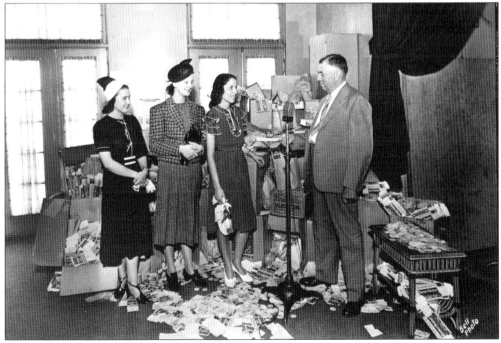

Many drives were held to help the war effort in the 1940s. The people pictured here are unidentified, but radio listeners evidently sent in their Fairmont Creamery milk bottle caps and wrappers to station KOBH by the thousands in response to a request. Fairmont Creamery at 201 Main was established in 1884. Otto Barnett was branch manager in 1939.

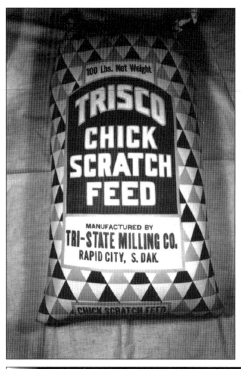

This colorful Trisco feed sack has an American Indian design that reflects its ties to the community. Besides Trisco feeds and flours, first manufactured in 1890, Tri-State Milling Company, which absorbed the old Rapid River Milling Company in 1929, also manufactured Swan's Down and Rushmore brand flours.

Tri-State Milling Company, presently Hubbard Feeds, has always been a good neighbor. Built in 1937, the landmark building had the finest in equipment and testing laboratories and was air-conditioned. During WW II, the firm twice received the War Food Administration and Army-Navy "A" award for outstanding war effort production and performance. In 1944, Tri-State was rated one of four top mills in the United States.

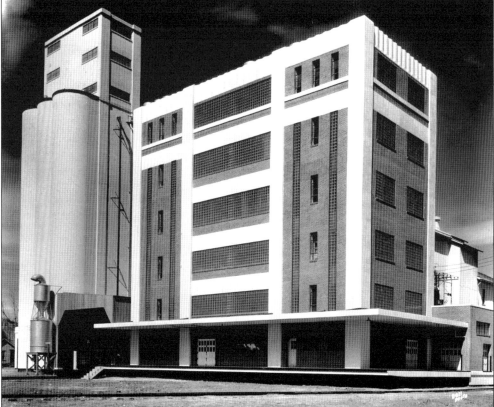

Nine

HEADLINES

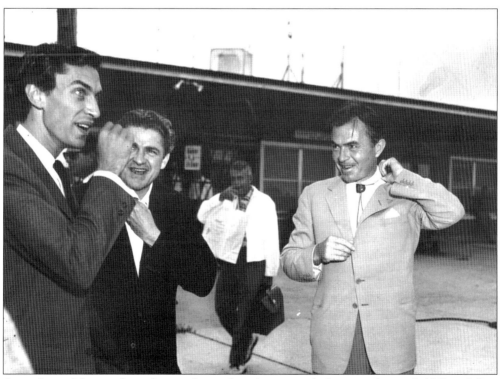

Actor James Mason adjusts his newly purchased souvenir bolo tie in front of old Rapid City regional airport and visits with fans. Mason, along with actors Martin Landau, left, Cary Grant, and Eva Marie Saint were in the Black Hills in September 1958 for the filming of Alfred Hitchcock's classic *North by Northwest*. The movie used Mount Rushmore footage in its thrilling finale. (Courtesy of *Rapid City Journal*.)

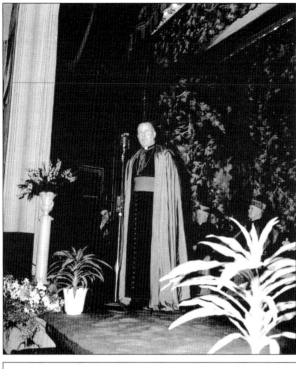

Cardinal Francis Spellman, archbishop of New York, speaks to a large crowd of loyal followers in the Rapid City Municipal Auditorium on May 8, 1947. His holiness, resplendent in a red cap and cape, was in attendance for the installation of Bishop William T. McCarty of the Rapid City Catholic Diocese, and was accompanied on his flight here by military escort.

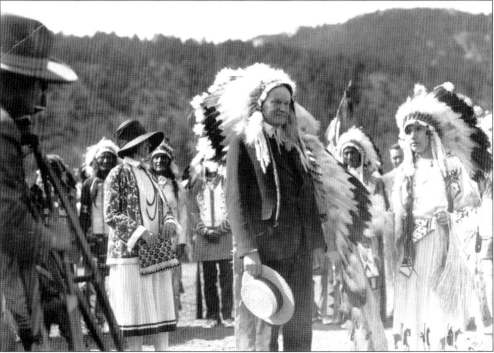

President Calvin Coolidge and First Lady Grace Coolidge enjoy a bit of the Old West as they are presented with authentic Indian regalia by Chauncey Yellow Robe and his daughter, Rosebud Yellow Robe, during the summer of 1927. The Coolidges vacationed in the Black Hills. The president was given the honorary title of "Chief Leading Eagle."

Legendary "Poker Alice" Tubbs was a real-life character who came to the Black Hills dealing poker in gambling halls. She was finally sent to prison in Sioux Falls, South Dakota for her shady past. In 1928, cigar-smoking "Poker Alice" was pardoned by Gov. W.J. Bulow because she was "75 years old, decrepit, and in ill health." She died in Rapid City on February 27, 1930.

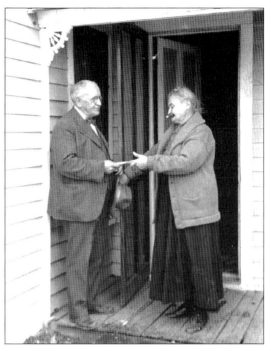

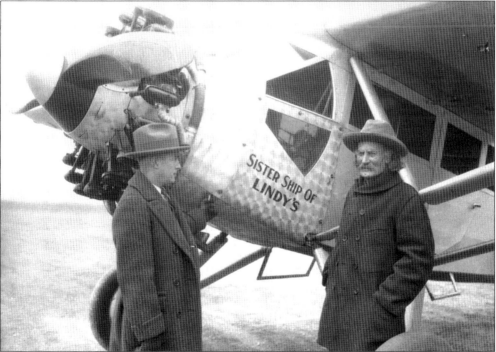

Deadwood Dick, aged 82, also known as Richard Clark, at right, stands by a replica of Lindbergh's Spirit of St. Louis airplane. Clark caused a sensation in the East in November 1928 as Black Hills boosters flew him and the plane on a junket to promote tourism. Clark even made a stop at the White House to present President Calvin Coolidge with some mementoes of the Coolidge's visit the previous summer. Dr. F.W. Minty is at left.

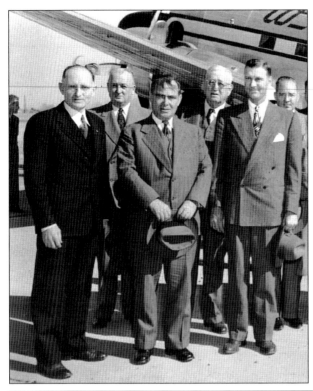

Joseph W. Martin Jr., center, Speaker of the U.S. House of Representatives, is flanked by South Dakota Senator Francis Case, left, and Gov. George T. Mickelson, right, during a Rapid City visit in 1948. Martin, from Massachusetts, was a former newspaper publisher who served his state and country in the political arena for 54 of his 82 years.

Charismatic President Franklin D. Roosevelt shakes hands with John Boland, center left, as he begins the motorcade taking him to Jefferson's dedication ceremony at Mount Rushmore on September 5, 1936. Boland was sculptor Gutzon Borglum's manager on the "monumental" project. Behind the wheel is local businessman and promoter Paul Bellamy, who is reaching for the hand of South Dakota Gov. Tom Berry.

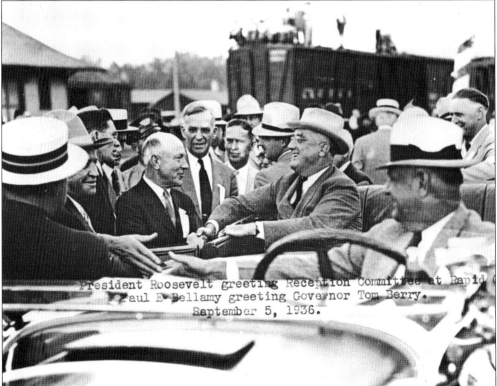

President Roosevelt greeting Reception Committee at Rapid City. Paul E. Bellamy greeting Governor Tom Berry. September 5, 1936.

Olympic great Jesse Owens poses for Bill Groethe's camera in 1938. Owens was in town with a traveling basketball team he hoped to bring to the stardom status of the popular Harlem Globetrotters. Enterprising Bill obtained Owens' signature and produced countless "autographed" postcards that he sold to school friends at bargain prices.

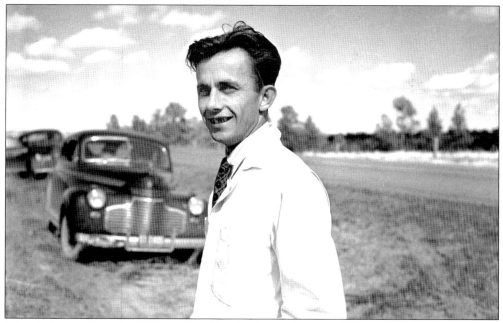

After being marooned on Wyoming's Devil's Tower for several days, parachutist Lt. George Hopkins attempted to set a record for successive parachute jumps in Rapid City in September 1942. What began as a publicity stunt concocted by two area businessmen became serious when Hopkins found he could not get off Devil's Tower. Flying ace Clyde Ice, unable to reach him, dropped supplies. Mountain climbers finally rescued Hopkins.

Rising from the Stratobowl near Rapid City to a world's record altitude of 72,395 feet above sea level on November 11, 1935, Explorer II conducted experiments in space for the National Geographic Society and the U.S. Army Air Corps. The balloon's envelope of rubberized cotton from the Goodyear Zeppelin Company covered nearly three acres before being filled with helium. Pilot Orvil A. Anderson and Comdr. Albert W. Stevens, captains, remained at ceiling height for four hours to collect important scientific data. The balloon stayed aloft a total of eight hours and 40 minutes before landing 225 miles east, near White Lake, South Dakota. Explorer II cameras took the first photos ever of the earth's curvature.

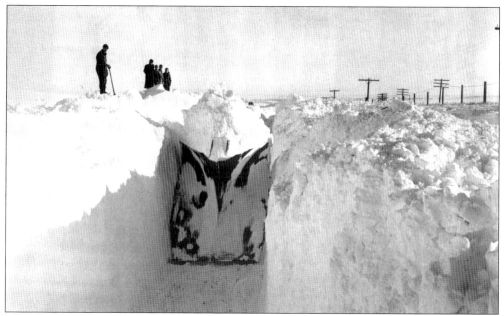

The "Blizzard of '49" was one of the most devastating major snowstorms to hit Rapid City and the Black Hills. It occurred January 2–4, 1949. Three days of snow, wind, and bitter cold froze gigantic drifts solid and caused high deaths of livestock. This Milwaukee Road engine was stalled east of town. (Courtesy of *Rapid City Journal*.)

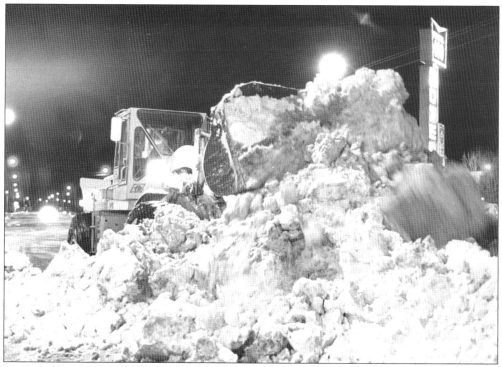

A city snowplow piles up snow to clear a downtown street during the winter of 1973, in a shivery scenario all-too-familiar to Black Hills residents. (Courtesy of *Rapid City Journal*.)

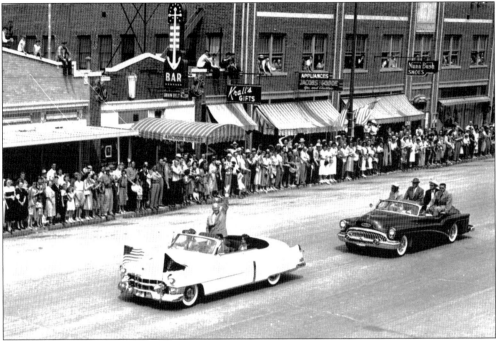

Waving to the crowd, President Dwight D. Eisenhower leads a downtown parade in his honor on June 11, 1953, welcoming him to the Black Hills. The Eisenhowers were the second presidential family to make nearby Custer State Park Game Lodge their summer White House.

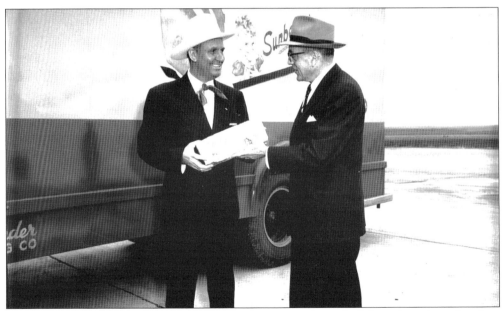

Cowboy Gene Autry is greeted by Swander Bakery's president, Carl Swander, who is handing him a loaf of Sunbeam Bread. Several movie stars were used in Sunbeam commercials—including Autry. The Gene Autry Show played two performances at Rapid City's auditorium on October 20, 1955. Featured were wonder horses Champion and Little Champ, Gail Davis (TV's Annie Oakley), Pat Buttram, musical groups, ropers, dancers, clowns, and acrobats.

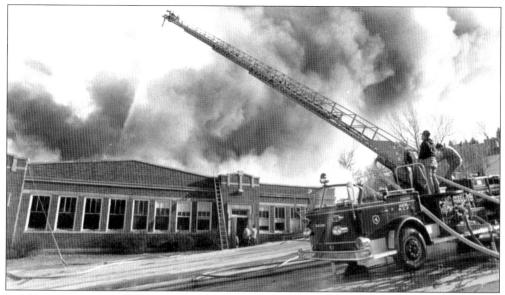

In addition to snowstorms and floods, Rapid City has had some spectacular fires, too. Washington School on Seventh Street went up in flames on December 4, 1970. Coolidge High School, to its right, was subsequently razed the following spring as a safety precaution because of its aged and oiled wood flooring. Arson was the cause of the blazing inferno. (Courtesy of *Rapid City Journal*.)

Gypsies numbering in the thousands flocked to Rapid City in early August of 1954 for the funeral of the Gypsy queen. Mrs. Frank Mitchell, 44, was leading a car caravan of Gypsies to a carnival in Rapid City when she was killed in an auto accident. Dressed in purple velvet and holding a silver coin, her services were held at Behrens Mortuary and Immaculate Conception Catholic church. (Courtesy of *Rapid City Journal*.)

Laura Bower Van Nuys was a member of the popular Bower Family Band in the late 1800s. Shown with her banjo, the former schoolteacher was honored when Walt Disney made her book into a 1968 movie called *The One and Only, Genuine, Original Family Band,* which had its world premiere in Rapid City. At left is talk show host, Tom Frandsen. (Courtesy of *Rapid City Journal.*)

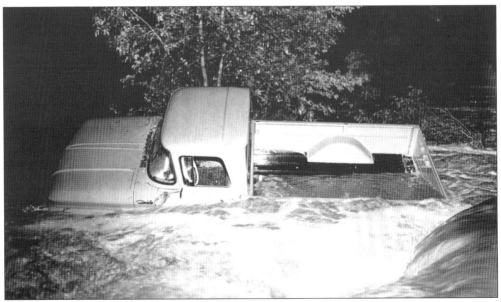

South Dakota's worst disaster occurred on the night of June 9, 1972, when heavy rains caused a flash flood that took the lives of 238 persons in Rapid City and outlying areas. The deluge created a wall of water that roared through town swallowing everything in its path. Torrents of water, like those pictured here engulfing an entire pickup truck, remain vivid memories for survivors. (Courtesy of *Rapid City Journal.*)

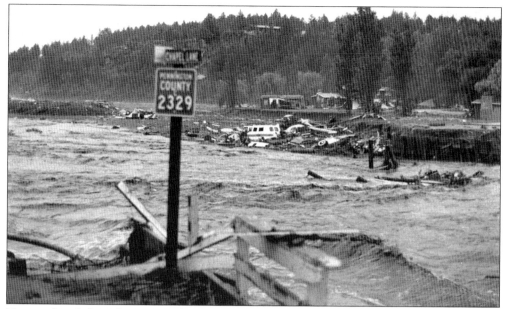

Not much is left at the crossroads of Chapel Lane and Pennington County Road 2329, after nearby Canyon Lake was sucked dry by the onslaught of what is still simply and quietly referred to as "The Flood." Reconstruction afterward altered the face and focus of Rapid City by creating greenway areas, safer buildings, and well-planned communities. (Don Polovich photo, courtesy of *Rapid City Journal*.)

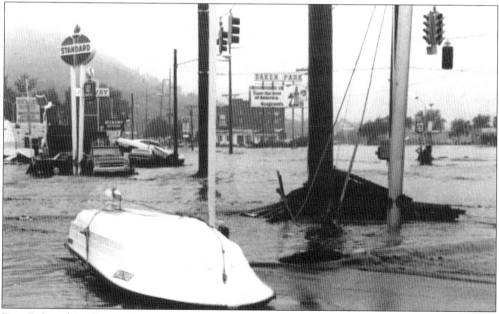

Don Polovich's aftermath photo of the June 9, 1972 flood reveals the intersection of Mountain View Road at West Main, near Baken Park Shopping Center. A gray pall and eerie stillness linger—unmistakable signs that something truly terrible happened here. Over 4,300 homes and mobile homes and 336 businesses were severely damaged or destroyed by one billion metric tons of churning water. (Courtesy of *Rapid City Journal*.)

"We Deliver" was the loud and clear message to Cold War threats from Rapid City's nearby affiliates Ellsworth Air Force Base and Rushmore air materials operations. A Strategic Air Command, or SAC base, the installations served as an integral part of a home defense system of Minuteman II ballistic missile sites.

Crew members of Ellswoth Air Force Base's 28th Bomber Wing proudly stand by a giant B-1B bomber. Ellsworth is one of few remaining B-IB bases in the nation and is an important presence in global military air power. Beginning as Rapid City Air Base in 1942, the facility housed the C-124 Globemaster, and in 1956, constructed the world's largest monolithic hangar for their RB-36 and B-52 warplanes.

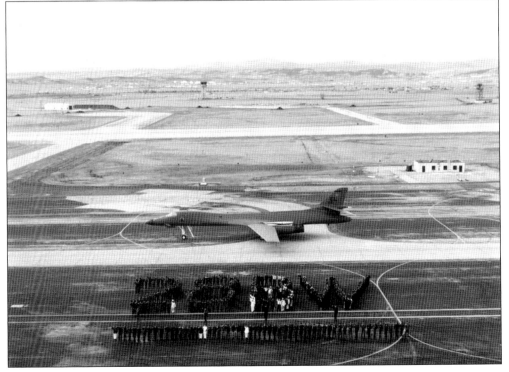